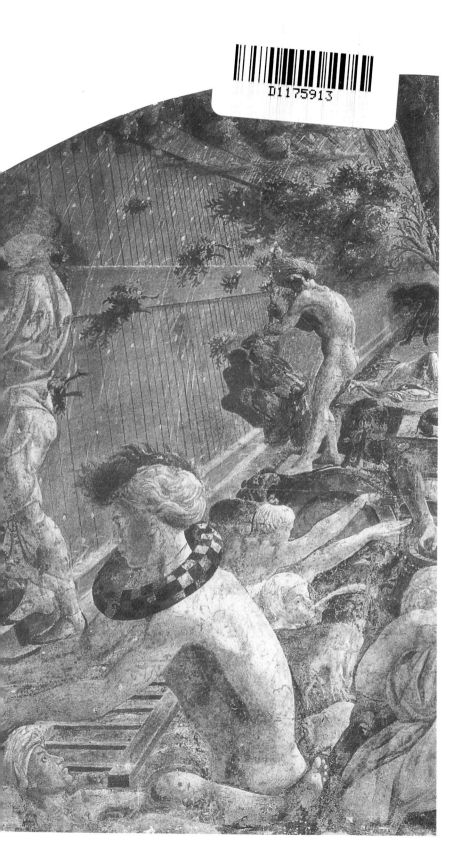

THE BODY, IN THEORY
Histories of Cultural Materialism

Editors
Dalia Judovitz, Emory University
James I. Porter, University of Michigan

Editorial Board
Malcolm Bowie, Francis Barker,
Norman Bryson, Catherine Gallagher,
Alphonso Lingis, A. A. Long,
Jean-François Lyotard, Elaine Scarry
Jean Louis Schefer, Susan Stewart

The body constructed by theory and through social and cultural practices has provided the departure point for studies that broach new fields and styles of inquiry. The aim of the series The Body, in Theory: Histories of Cultural Materialism is to reconstruct a history of materialisms (aesthetic, linguistic, and philosophical) by locating the body at the intersection of speculative and cultural formations across a wide range of contexts.

Titles in the series
The Subject as Action: Transformation
and Totality in Narrative Aesthetics
by Alan Singer

Power and Knowledge: Astrology,
Physiognomics, and Medicine
under the Roman Empire
by Tamsyn S. Barton

Under the Sign: John Bargrave
as Collector, Traveler, and Witness
by Stephen Bann

The Deluge, the Plague:
Paolo Uccello
by Jean Louis Schefer,
translated by Tom Conley

THE DELUGE, THE PLAGUE

Paolo Uccello

BY
JEAN LOUIS SCHEFER

TRANSLATED WITH
AN INTRODUCTION BY
TOM CONLEY

Ann Arbor
The University
of Michigan
Press

Published in the United States of America by
The University of Michigan Press
Manufactured in the United States of America
⊗ Printed on acid-free paper
1995 1996 1997 1998
1 2 3 4
*A CIP catalogue record for this
book is available from the
British Library.*

Library of Congress Cataloging-in-Publication Data

Schefer, Jean Louis.
 [Le Déluge, la Peste—Paolo Uccello. English]
 The Deluge, the Plague—Paolo Uccello / by Jean Louis Schefer ;
translated by Tom Conley.
 p. cm. — (The body, in theory)
 ISBN 0-472-09519-6 (alk. paper)
 1. Uccello, Paolo, 1397–1475. Flood. 2. Uccello, Paolo,
1397–1475—Criticism and interpretation. 3. Deluge in art.
4. Mural painting and decoration, Italian—Italy—Florence.
5. Santa Maria Novella (Church : Florence, Italy). I. Title.
II. Series.
ND623.U4A66 1995
759.5—dc20 94-38299
 CIP

FOREWORD

Stephen Bann

A publication of this kind inevitably gives rise to a question: Why translate a work by Jean Louis Schefer, and why his *Le Déluge, la Peste* in particular, at this moment in time? It is a question partly, but not wholly, answered by the fact that Schefer's study is being presented here, nearly two decades after its first publication, in an exciting new series: The Body, in Theory. For this simply puts the issue back a further stage. What is it that gives *Le Déluge* its timeliness in relation to the cluster of issues that have helped to determine the character and direction of the series?

Over a somewhat longer period than these two decades the fresco of the *Flood* by the Florentine painter that forms Schefer's almost exclusive subject matter has itself been expelled, by flooding, from its original location in the Lower Cloisters of Santa Maria Novella, and reerected, after restoration, in a site closer to the church. This little episode could be seen as a parable for the comprehensive reordering, and reassessment, of the human sciences, with their French-derived paradigms, which began in the early 1970s and has not ceased up to the present day. What has been labeled as a shift from structuralism to poststructuralism or, on another register, from modernism to postmodernism, constitutes less a break, however, than a strategic resituating of earlier concerns.

Roland Barthes was one of the first to recognize that Schefer's work, distinctive both in its method and in its subject matter, formed a major intellectual turning point. In his generous and perceptive review of Schefer's first book, *Scénographie d'un tableau* (1969), he commented that this extended study of a Venetian painting, Paris Bordone's *Game of Chess,* marked a decisive new tendency in the development of semiology. In its classic period semiology (and semiotics) had operated as if there were an ideal

structure, or model, to which individual works corresponded in an approximate fashion: each work had to be seen as a kind of "divergence" (*écart*) from the norm. But for Schefer the image was not the expression of a code but, rather, a work of coding, not the depository of a system but a way of generating systems.[1]

Barthes has a sideswipe at "interdisciplinarity," "the cream tart of the new university culture," in order to prove his point that Schefer's implications are not confined merely to the semiology of art. It is not because he has "applied linguistics" to the exegesis of a painting that his approach is so fertile. It is because he has sought to annihilate the institutionalized distance that lies between the painting and the text. In that way he opens up the possibility of a kind of writing that is no longer "criticism" or "aesthetics," but, instead, one that defines itself in the very process of engagement with its materials.

Only this summer, from a *vaporetto* chugging along the Grand Canal, Schefer pointed out to me the Venetian apartment in which he had compiled his study of the *Game of Chess* in the 1960s; and, as it happens, my first opportunity to see the painting itself in the National Gallery, Berlin, had been in the summer of the previous year, when I had been astonished by the sumptuous, Titianesque coloring of the original, after conceiving it so long in terms of Schefer's black-and-white photographic reproduction. My point in mentioning these stray factors is to suggest that Barthes was right about the general movement of Schefer's writing, but at the same time a great weight was still exerted, in *Scénographie d'un tableau,* by the sheet anchor of "classic" semiology. This treatise written in Venice about a Venetian painting on the other side of the Alps still kept at bay important aspects of its materiality, transforming it into an exemplary object of demonstration. Indeed, its most decisive function may have been to draw attention to the intolerable complications of a method that ostensibly based itself on simple, semiological presuppositions and yet took that method close to the point of collapse.

Barthes used the occasion of his review of *Scénographie d'un tableau* to ask: "Is painting a language?" Schefer's *Le Déluge,* then, takes up this question in a specially striking way, by insisting on the absolute specificity of the painting as a vehicle of representa-

tion. For him "this capacity-to-mean belongs only to the painting
. . . and it's a power of *hapax*: of a text without redundancy that is
pluralized upon single instances." By invoking the classical gram-
marian's concept of the *hapax,* or *hapax legomenon,* he means us to
think of the analogy of the word for which the dictionary supplies
only one recorded use: a word whose meaning is therefore insep-
arable from the specific verse or sentence in which it makes its
unique appearance. Barthes's original intuition that, with Schefer,
semiology was already escaping from its dependence on the con-
cept of an ideal model thus finds an unequivocal confirmation. As
Schefer himself expresses it, "What plays on and in the represen-
tation . . . is not just an instant summation of the discourse *be-
hind* the figures, but a summoning of language placed in a scene
of impossibly specific writing."

I imagine that I have done enough to show, in very brief terms,
that *Le Déluge* indicates a movement away from the imperialistic
semiology of the 1960s and, indeed, a reversal of its methodologi-
cal emphasis. But the question now is why this insistence on the
specificity of the scene of painting (and writing) should have
achieved a wider cultural resonance: why it should have proved
(and still proves today) not so much an eccentric fetishization of
the painter's craft as a forceful revelation of the ideological stake
invested in the image. In recent years art history has taken a few
halting steps in the same direction, and there can be no doubt
that this is a major reason for the timeliness of this translation.
But it is probably still necessary to think of an alternative tradi-
tion, untouched by the model-based interpretative procedures of
iconography and iconology, in order to give *Le Déluge* its wider
significance.

One way of doing this is to return, once again, to the Grand
Canal, where John Ruskin "saw the last traces of the greatest
works of Giorgione yet glowing like a scarlet cloud, on the Fon-
daco de Tedeschi." The "Hesperid Aeglé," as Ruskin termed it, is
recreated in a black-and-white engraving at the head of one of the
last chapters of *Modern Painters* vol. 5, but the text itself is a
meditation on what the illustration could not convey and what
time and weather have, in any case, dilapidated beyond repair:
the "glowing colour" of the one remaining figure, which Ruskin

supposes to have been "pure vermilion." Yet this passionate evocation of the vanished "power" of the colored image is counterpoised with one of Ruskin's last long speculations on the moral and artistic strength of the work of Turner, whose *Liber Studiorum* includes as its frontispiece an emblematic vision of the fading light: "Tyre at sunset, with the Rape of Europe, indicating the symbolism of the decay of Europe by that of Tyre, its beauty passing away into terror and judgement."[2]

In citing Ruskin in this fashion, I am declaring a wide-ranging but not for that reason loose comparison between Schefer's writing and the English tradition of "aesthetic criticism." (A further, and perhaps even more illuminating, comparison could be made with the more recent critical work of Adrian Stokes.) The point is that, for these authors, writing becomes the site of an encounter with the work of painting whose boundaries cannot be fixed, because the goal is not an attribution, or an iconographic decoding, but precisely an examination of the Western individual's stake in the image. For Ruskin this results in a memorable acknowledgment of the ambivalence of color, which is "the type of Love" and so can either lead to "corruption" or be "the holiest of all aspects of material things." His later writing is wracked by this formidable tension between the sexual element in color and its would-be sublimation, so that the very structure of his argument seems to have been broken in the process.

Schefer's *Le Déluge* is not, in this sense, the enactment of a discourse that has begun to fly apart through the pressure of the tensions to which it gives rise. And yet its characteristic movement is, indeed, fleeting and its argument fissiparous. Schefer refuses to be the master of the scene of representation, as if it were possible to make the figural forms of Uccello's fresco dance in front of us like well-trained marionettes. Instead, he chooses a position, as it were, in extreme proximity to the fresco itself: not to the physical object (whose successive restorations in the course of the last half-century have, in fact, given rise to acrimonious debates) but to what might be called the "cultural object," insofar as it is the product of a history that continues to manifest itself across the abraded and chalky surface.

Ruskin called the lingering figure of Giorgione's Fondaco de Tedeschi a "scarlet cloud." For Schefer the noncoincidence be-

tween the figuration of corporeality and the effect of color is even more emphatic: the brown and grayish tonalities of the *Flood* fresco serve as a kind of matrix in and out of which these bodies slip continually. Here, as elsewhere, Schefer's intuition is supported by his parallel knowledge of certain aspects of contemporary painting. Only two years after the publication of *Le Déluge* he summed up the special character of the paintings of the Italian artist, Titina Maselli, with the phrase: "Colour is not a site: here it seizes hold of a body whilst it is in the process of turning away."[3]

What, then, is the reason for this insistence on the elusive nature of the body in representation? Having already mentioned Ruskin, I could also bring into account a further striking example of the equivocal role of the body in the critical writings of D. H. Lawrence. In "Introduction to These Paintings," Lawrence develops an ambitious hypothesis about the alienation of Western man from his own body, which he links with the onset of venereal disease in the early part of the modern period. Only the painter can hope to proceed a little in the direction of remedying this alienation, but the painter is obliged to work through a detour. Thus, Cézanne goes further than any other modern artist in restoring the reality of the body through representation: in a deliberately christological comparison Lawrence acclaims him for "shov[ing] the stone from the door of the tomb." But even Cézanne cannot paint the body, and it is only in his still lifes, his celebrated "apples," that the process occurs.[4]

I cite this further instance of a disquisition on the body in order to broaden, yet again, the context in which Schefer's work as a whole may be set. But I am not, of course, implying that his role is merely that of recycling myths about the body whose relative eccentricity and crudity (judged from our point of view) gives them no more than a symptomatic value. Schefer may well provide an echo of Ruskin when he writes, in an essay that forms a stage on the way to *Le Déluge,* of the "West where colour is seen only at its setting."[5] He may call to mind Lawrence when he insists on the necessity of taking into account the complex Christian theology of the body, when discussing the figure's implacable resistance to representation. But the crucial point is that he does so in full knowledge of the project that he is undertaking. In fact,

it would be true to say that he has not ceased to work on the same project, from 1976 and before, up to the present day. His unremitting attention to the major issues left (but left unresolved) by the French *maîtres à penser* of the 1960s has continued to bear fruit.

Barthes himself heralded the fact that, with *Scénographie d'un tableau,* semiology was leaving the realm of "the Model, the Norm, the Code, the Law—or if you prefer it: of theology." Yet, if it is perfectly true to say that Schefer was abandoning the theology of the sign, it is equally true to insist that he was entering the regime of theology. As Tom Conley clearly shows in the introduction that follows, Schefer's founding work on the theology and psychology of the "Christian body," *L'Invention du corps chrétien* (1975), is the immediate precursor and, indeed, precondition of the work on Uccello. It is precisely in his concern to specify the conditions for the emergence of this new cultural construct, out of the "corruption" of paganism, that Schefer is drawn back to painting, after his opening dialogue with the Christian texts. Uccello's *Flood* is, after all, a representation of the most potent of all myths of regeneration that mark the passage from a corrupt to a potentially redeemed new world. The praying figure of Noah stands guard over a scene of deliquescence and decay, which is, however, already glimpsed in the light of its metamorphosis.

On more than one occasion in *Le Déluge* Schefer makes reference to another work attributed to the artist: the *predella* painting of the *Profanation of the Host* kept in the Ducal Palace of Urbino. It is a good indication of the overall continuity of his research that he should now be working on this very different aspect of Uccello's production. The link exists, of course, not in any obvious resemblance between the jewel-like, miniaturized scenes of the Urbino panel and the faded, earthy ground of the fresco but, instead, in the theological complexity revealed by the scene of the *Profanation,* which plunges us back into the legal and symbolic systems of the ancient world, only to stress, by contrast, the distinctiveness of the Christian body. This happy coincidence between two phases of Schefer's work on Uccello, which will be emphasized by the appearance of the present translation, is thus a further reinforcement of the interconnected nature of his concerns. It should remind his audience that, though he has written

many other books between 1976 and the present day, he has not in any sense abandoned the cultural logic of his earlier positions. Nor have we yet been given so good an opportunity of catching up with him.

NOTES

1. See Roland Barthes, *L'Obvie et l'obtus: Essais critiques III* (Paris: Seuil, 1982), 139–41.

2. John Ruskin, *Modern Painters* (London: George Allen, 1897), 345–71.

3. See Jean Louis Schefer, *Titina Maselli—Trajets lumineux* (Paris: Christian Bourgois, 1978), 5.

4. See D. H. Lawrence, *On Hardy and Painting,* ed. J. V. Davies (London: Heinemann, 1973), 146ff.

5. See Jean Louis Schefer, "Spilt Colour/Blur," trans. Paul Smith, *Twentieth Century Studies* 15–16 (December 1976): 82–100. This text is included in a selection of writings by Schefer, edited and translated by Paul Smith, which is due to appear from Cambridge University Press, New York, in the series New Art History and Criticism.

CONTENTS

ILLUSTRATIONS
Facing page 112

INTRODUCTION
Writing Painting

Tom Conley

In *Éléments de l'interprétation* and other writings devoted to
the clinical perspective of psychoanalysis Guy Rosolato
notes that visual traits betray the texture of many of his
patients' speech.[1] Verbal fragments that the analysand utters
move at once toward and away from pictographic areas that the
activity of speech is putting in view. A "picture" of discourse re-
sults, such that certain fragments of vocables convey material
qualities akin to brushstrokes, smudges, dots, bits of masking
tape stuck to words, or even vanishing points of an imaginary
painting. Once the analyst manages to see these elements the
world of the interlocutor's memory becomes, for a moment, tan-
gible. Retinal persistence of these figures in a flow of speech offers
a glimpse of the mental world that the speaker generally fails to
discern. By conceiving of speech in these terms, Rosolato implies
that a speaker confronts his or her memory as if from the stand-
point of an individual standing on the stage of a circular theater:
on all sides are the images of the past that speech tends to animate
or identify. When details of the past are designated a *visible*
speech is uttered. Its content is conveyed in the same kind of
rebuses and "hieroglyphs" that Freud describes in the *Traum-
deutung;* they appear as bizarre figures emerging from a field of
discourse that switch the patient's discourse into pictural form
for a brief moment before, once again, they disappear into the
flow of speech.

The Deluge, The Plague (orig. *Le Déluge, la peste*) begs the reader
to study its discourse in this way. A scatter of visual traits, what
Rosolato calls "perspectival objects," typifies both the writing of
Schefer's essay and the painting that it studies. Schefer implicitly
asks us to read his work as if we were analysts and, like Rosolato,
to see how verbal and visual fragments betray what he is stating

about Paolo Uccello. By virtue of the difference that he discovers between the *pictural* aspect of a patient's speech and the *verbal* field of its meaning, Rosolato discovers areas in which elaborate systems of expression and repression offer clues about how elaborate scenarios and theaters of communication are constructed.[2] The task of the analyst, he argues, entails discovering how these visual points are related to the traumatic moments of birth, separation, anguish, and painful entry into language that every human subject reenacts from the beginnings of life. The analyst, in fact, likens these optical forms to transitional objects that are held *within* the realm of speech and that couple and uncouple the interpreter's relation with his or her individual past as well as, collective forms—images, shards of speech, objects glimpsed— that shape human growth and development at given moments in history.

Analysts, he continues, must continually remind themselves of their need to *see* the discourse they are hearing. Using a method of "free attention" that allows the ear to listen the way stalking hunters let their eyes be receptive to movement all over their field of vision, they must try to *listen to* fragmentary rhythms or patterns that do not obey laws of grammar. Somehow these shards of speech are arranged as visual allegories, like Baroque paintings and architecture, but, unlike those masterworks, they lack standard manuals—such as Ripa or Valeriano—for ready-made decipherment. The interpreter must hence study the plastic effects of discourse and work, no less, with and through its physical movements. The latter are defined, if a metaphor can be mixed, in part by momentarily fixed points that serve as coordinates of an imaginary geography. Rhumbs and rhumblines, or figurative wind roses, visible vectors of speech, organize the patient's advance and retreat into language in the very act of speaking or writing.

At the same time they sparkle with memories that are, on rare occasion, dimly fathomed images that surge up, simultaneously, into the present. We experience the effect routinely: often when we are speaking with others our memory brings forth private images onto a screen that at once reflects and blocks our sense of what we think we are conveying. We let our speech go on "automatic pilot" as memory flashes through our reason and distracts

us. When sensing that the patient's relation with commonly traumatic memory is being discovered, the analyst glimpses these visual "points of speech" that betray the subject's relation with the unknown. They are located at an interface or a focal point between what is visible and audible. They can be located only relationally, as if the analyst were an early modern navigator, equipped only with an astrolabe, an hourglass, and a bearing on the North Star, who charts a vessel's movement without any shoreline in view. By means of dead reckoning, both interpreter and patient move toward the lines of embryonic folds, where every subject is twisted or creased into conscious life.

The Deluge is exactly that: a writing of painting, a text executed on a fresco of language that serves as a mute interlocutor between an imaginary author and public. In this book Paolo Uccello's *Scene of the Deluge* plays the role of a silent analyst at the same time that it furnishes a collective mass of memory toward and away from which the writer's body moves. Schefer navigates, or "works through," the Florentine painting in order to uncover bits of memory that indicate how our lives reckon with an unconscious and how that unconscious colors the fabric of our lives. Thus, the style of *The Deluge* is unlike anything we know in realms of art historical, critical, or even literary genres.

Schefer does not assume an omniscient pose seeking to convince us that he "knows" the life, works, and contributions of Paolo Uccello or that he can fit them into a scheme of cultural history. Nor does the writing prop up a relation of identification—a fixed point—that would mark a historian's dedication to the life and work of his chosen painter. Yet neither does Schefer's plan reveal anything of a narrative that recounts a spiritual journey through a work that might move from opaque beginnings to a sense of enlightenment. No Artistotelian "plot-points" of a commanding narrative emerge enough to guide us through its labor of history, autobiography, or analysis. Rather, the psychoanalytical construction of *The Deluge* might be likened to an abstract painting of words, in which the stakes and effects of Schefer's encounter with Uccello are literally spread *all over* the surface of the discourse.

The book bears the impression of a series of autonomous fragments organized under emblematic subtitles. They are juxta-

posed to one another; in aggregate they form a continuous, or entirely serial, reflection. Yet, at the same time, its five chapters (the scene, the plague, animals, the gods, and the mazzocchio) imply that both a theatrical design and a five-act play lead the reader toward and back to a strange denouement, the faceted, circular design of a fifteenth-century Florentine headdress. A *mazzocchio,* a stylish Florentine wicker coiffe worn in well-to-do circles, is placed on the head of a young woman (or androgyne) who straddles a bull and holds a figure bent over the beast's mane in the foreground of the fresco. It seems to turn like a cogwheel along the arc of a spinning barrel from which emerges a chalky image of the painter—perhaps Uccello or maybe Schefer—sporting a loose turban and clothed only in a scant pair of wet underwear. He seems to surge out of the mazzocchio or to be lowering himself into it. His genitals sprout up from its hub like a trumpet-shaped mushroom. To the immediate left another mazzocchio bedecks the neck of a young man brandishing a massive club. It bears vague resemblance to a small inner tube, or buoy, that children use to float when swimming in water over their head. The same object is aligned with a wooden mopboard that is set in a perspectival view that leads back a hub resembling the flywheel of a great propeller at the end of the imaginary wind tunnel that encloses the inner space of the painting.

The mazzocchio would thus seem to figure in the rotating mechanism of *The Deluge* but also stand forth as an enigmatic object set between the verbal and pictural dimensions of Uccello's fresco. It seems to be a chessboard folded into a prismatic circle and to be inserted in the work as a black-and-white, contrastive agent that brings out the surrounding mass of tan, red, and siena hues. The object marks a transitional point between a late-fifteenth-century Florentine world, Uccello's research on perspective, and the art of trompe l'oeil—cultivated in wooden inlays, marquetries, and intarsia—which contrast the medium of the fresco.[3]

But insofar as the last act of the drama leads to the mazzocchio, the overall "theater" of the painting is located by virtue of its perspectival configuration: the Florentine headpiece conflates the verbal and visual design of the painting and, like a calli-

graphic design or a rebus ("*mazza,* the bludgeon, the club, the painter's maulstick; *occhio,* the eye of the painting, the gaze of this spinning object" [47]), it becomes a transitional object that recalls as much the origins and ends of the work's visibility as the depths of its memory. The mazzocchio's prismatic circle offers a clue to the composition of *The Deluge.* At the beginning of the essay Schefer surmises that "we would have to inquire of the tradition of the memory-arts . . . that accompanies the growth and construction of the figurative field" (25). He wants to see how the historical subject is parcelized, fragmented, and scattered over different fields. He implies that "The Scene of the Deluge" places on a vertical axis the groundplan of a Vitruvean memory theater, whereas the converging lines in the background lead to and from the vantage point of the viewer, who gazes at the work from a horizontal view. An optical system recalling Alberti is superimposed upon an intellectual design built from circles and triangles in Palladio's reconstruction of Roman world theaters.[4] Our view of the painting can thus be *both* scenographic and ichnographic. If we imagine ourselves looking at the work from a bird's-eye view, the vanishing point of the *The Deluge* would occupy the site where we might "see" the entirety of the history of representations of plague. The surrounding environs would be sides of a circular theater with panels arranged as the sides of a polygon. From a horizontal point of reference we would study the painting as a scene that gravitates toward the "eye" of a storm that spins about an axis in the background. The mazzocchio seems to suggest that the work can be approached from both views and thus include a dimension of memory in its visual field. Thus, as a transitional object that relays the trauma of the painting's origins and that allows it to slide into a symbolic arena of recognizable names and forms, the mazzocchio also helps us locate how Jean Louis Schefer goes about his writing of painting.

Schefer's writing, obscure as it is exhilarating, appears to be composed from both points of view at once. It is above and facing the work. The mixed mimetic effect that results is owed, too, to the writer's appeal to at least three disciplines. The most commanding is, of course, the intellectual history of art and literature, but only insofar as it is inflected by the adventure of psycho-

analysis and the author's extensive training in semiotics. *The Deluge* was published in 1976, on the heels of two very different studies of religious history and the semiotics of art. In *L'Invention du corps chrétien* (The Invention of the Christian Body [1975]) Schefer took up the ways that Saint Augustine virtually "organized" an interpretation of Christian experience—and the way that every Christian subject is impelled to think of and live the life of his or her body—through phantasmatic means. In order to argue for Christian ideology the patristic author showed that the pagan body had to be reconceived—or reinvented—if Christendom were to win over other competing systems of belief.

In the pagan world the body was felt to be a plastic shape with perimeters defined not only by an individual consciousness but especially in relation to realms of other bodies and things constituting the physical universe. According to this view, the body knows no sharp division between death and life; it can indifferently be attached to or separated from myriad objects and forms; it participates in a vast mythology through which its identity changes according to narrative fantasies that recombine human and animal activity into endless braids, which weave together memory, reason, and sensation. The kind of pagan life that Saint Augustine reorganizes is too complicated, too sensuous, and too unsettling to be controlled through the enterprise of a monotheistic (or monocular) belief. Nonetheless, for Saint Augustine new and simpler intellectual schemes have to be instituted. They would have little appeal were they entirely to deny the wealth of pagan forms. In every event (as the last pages of *The Deluge* insist) coherent organizational mechanisms must be conceived to categorize and reshape the experience of ordinary life. Different modes of taxonomy are needed to reorganize pagan forms.

Such was the Augustinian design. Attempting to insert a "lapsarian" moment into history, it opens a divide between a past and a future. In doing so, it conceives a new "dictionary" of words and shapes that recategorizes the body's experience.[5] From a point of departure, or fall, guilt figures at the center of human experience; loss and consequent melancholy begin to affect the subject who invests in Christian belief. According to Schefer, Christian sub-

jects who rehearse their religious past are also obliged to return to the traumatic moment of this invention of the body. In a delicate and ineffable way the return follows a well-beaten Freudian path. Christian memory arches back to a threshold between a half-human, half-animal world of flow and of unbound energy that knows no distinction between things living and dead. The area beyond (if Julia Kristeva's classical schema is recalled) tends to be more "semiotic," or free-flowing, than "symbolic," or constrained by a univocal language or simple categories of experience. In the course of an analysis the Freudian subject will "return" to this indeterminate and richly indifferent state of energetic flow. In psychogenetic terms it is likened to a timeless condition that seemingly exists "before" symbolic controls of memory are imposed upon the body. In its realm are discovered palettes of indistinct visual forms mixed with all kinds of sounds and noise. Subjects who seek to rediscover the past glimpse details of their growth into the world at the point before or synchronic with their entry into the frame of language. In this way everyone "remembers" something of a pagan past within the field of ordinary memory.

That past is, however, a historical product of the body, a locus of conscious and unconscious attention, set in counterpoiṇt with two inevitable facts of experience: the process of aging and the coming of death. Decline and death constitute perspectival objects for intellectual labor applied to the human body. The return is a voyage, and, because it is discursive in nature, its passage is visible in the flicker of intermittent and unpredictable illumination.[6] For that reason we might say that *The Deluge* intervenes in Schefer's writing career as a work that takes up the emergence of an autobiographical body inspired at once by his *Invention du corps chrétien* and the highly topical art historical study, *Scénographie d'un tableau*, which had been published five years before (1969). In the work on Saint Augustine, Schefer turns inward, into the murky past of seventeen centuries of Christendom, to retrieve the liminal area between a pagan body of nature, a world imagined as one of sensuous savagery, and that of a "foliated," paginal body organized through Scripture. Schefer traverses autobiography, hagiographic images, Christian transcription of

7

primitive scenes, and bits and pieces of contemporary forms—
that embody the same past—as he seeks a threshold between the
pagan and modern body. But in the *Scénographie* the author ap-
pears to write a highly controlled work, a formal *morceau de ré-
ception,* which organizes descriptive traditions of art history ac-
cording to a scheme of differences and pertinent traits taken from
linguistics. At first glance its study of a double portrait, Paris
Bordone's *Chess Game* (executed between 1550–58), appears
only marginally related to the future labor of autobiography and
religious history.

The contrast is only ostensive. In the *Scénographie* Schefer ex-
amines how Bordone's painting presents the spectator a Vitru-
vean theater staging the perpetual rebirth of visibility. The paint-
ing, a portrait not only of two chess players or a split representa-
tion of a single figure, is also "a portrait of the painting" itself,
which designates "the space of its own representation," of a space
"portraited" (*portraituré,* 9). The analysis shows how, as specta-
tors, we figure at the double optical center of the work, at the axis
of a theatrical memory system. We are defined at a vanishing
point outside of the work that is, paradoxically, also *within* the
painting, reflective of Bordone's staging of a play of visibility and
invisibility and of savagery and death. Bordone's work pulls us
into a world of vision and memory, of bestiality and culture,
which is forever split and splintered. We find ourselves looking at
a black-and-white chessboard in scenographic view that is set in a
triangular relation in respect to our gaze. Our eyes are led to the
checkered surface and then move toward the players, who gaze
upon us as we gaze upon the board. The black and white squares
define the order of peripheral scatter of flora and fauna all about
the rest of the painting. The jagged line of the black and white
edges of the playing surface gives way to a similar zigzagged line
forming a precipice of marble tiles that cuts an accidental course
between the world of savagery—nature—on the right side and
the elegant classical theater of culture on the left.

From Bordone, Schefer develops a semiotics of "scopic" drive
to engage universal memory. In the *Scénographie* pieces of Lacan's
model of scopic distortion (appealing to Hans Holbein's experi-
ments with anamorphosis) that study the relation of the con-

scious and unconscious are complicated by a historical trajectory: the painting offers a webbing of sight lines that organize a culture's fantasy of death, erotic attachment (the tactile presence of erogenous sites, such as a nipple figured as the button of a chesspiece gently squeezed by the dexter player's thumb and index finger of the right hand), and bodily dismemberment. The painting arches back to an "invention" of the modern body through a systematic regress to a condition of savagery, located as a surrounding orbit of nature that constitutes the painting's background and right-hand side. Bordone encourages us—thanks to Schefer's itinerary—to work back and through to the perspectival object of the image to our own imbrication in its trajectory toward death. He shows how the painting organizes an array of myths about bodily violence into an uncanny "system" that calls into question the ideological position of a spectator belonging to any time or condition.

Through Schefer's treatment the painting begins to psychoanalyze the viewer. It also theorizes the optical workings of constructions that represent the Christian past. Historically, the *Scénographie* forms a panel in an allegorical landscape of Schefer's own career prior to his writing of *The Deluge*: on the left, in the remote past, in a world of painting, a study of linguistic and visual systems that invoke age, decay, and delirium; to the right, in a textual world, in autobiography, displays of Christian manipulation of these same forces. The treatment of Uccello's fresco draws heavily on the studies of Saint Augustine and Paris Bordone's writing and becomes clearer when seen from their perspectives.

As noted, *The Deluge* is conceived as a drama and a textual reinvention of the Christian body in a great Vitruvian memory theater. The work begins and ends on the whirligig of the mazzocchio but also leads toward and declines away from a vanishing point, near the center of the study, in which the title of Schefer's work recurs:

> None of these bodies [in *The Deluge*] has ever been stationed in the painting; we seem to witness a strange unveiling of the figurative body in the middle of Christendom: what does it bear? Nothing. It is a cloud of mist, a fold in color.

9

A sudden unveiling: of catastrophe—*the deluge, the plague*—
that brings to light its inconsistency, its division (the image is
never, in all the history of its theory, that is, other than the
identity-crisis of the logic of the predicate, anything more than
what expresses not a resemblance but a division) and makes
"appear" [*paraître*] a "grazing" [*paître*] (like a flock of sheep), its
archaism: its memory, in other words, its pagan reason. (88,
emphasis added)

The title is slipped into the discourse in order to remind us that
we are reading a literal writing *of* painting and that the construc-
tion of Schefer's own discourse assigns a place for the title at a
vanishing point in the text of the essay. A divided origin remains
in the axis, in a fashion akin to Uccello's painting, from which
emerge a wind of plague (a tempest), a swelling of black waters,
worlds of floating islands, and a battle of human figures on a
surface that resembles a great tongue adrift in the palette of a
mouth-like world.

We might say that Schefer *folds* the title into his work in order
to liken his project to the study of a catastrophe, a bending or
creasing, that marks the invention of the Christian body. He does
so from within the body of the essay itself and in dialogue with
Leonardo. Early on in *The Deluge* Schefer notes that da Vinci's
precepts on painting are related to bodily folds: "In painting the
body is only an additional fold" (53). He seems to be defining
catastrophe literally, as a fold whose creases define the passage of
myth into history. In Uccello it is synchronous with the advent of
deluge and plague on the horizon of European history. Thus,
when we behold human shapes that fold themselves into the
landscape of the painting, we witness a phantasm—Uccello's,
that of the Black Death, of the birth of history itself—in terms
that recall our own origins and that are everywhere palpable on
our own bodies. Through the painting we recall how human form
develops embryonically from a play of folds at the same time that
for Uccello painting entails a pleating and hemming of surfaces.[7]
In the fresco the body has to be broadly understood, as an ag-
glomeration of flat and twisted planes that develop from the birth
of figuration reenacted in plaster on the wall at Santa Maria No-
vella. Billowing in the wind and swelling in the flow of water, the

figures make continuous a collective and primitive memory of bodily and historical origins.

As in a work of modern art, a serial articulation of an originary catastrophe takes place *all over* the surface of the painting. It is visible in the effects of the clothing that the players wear, in the heaps of rags that remind us of the painter's cloth used to moisten and clean the plaster surface, and in the blotches and scratches that betray the work's aging and wear over five centuries. Also plied into the fresco is an almost calligraphic, or literal, rendering of medieval and modern narratives of plague (Boccaccio, Michelet, Artaud) and of universal declension (Varro, Vico). The text of Uccello's painting virtually accounts for eruptions of tempest and plague both within its time and at other epochs that come before and after.

Schefer endows the fresco with historical elasticity through appeal to the religious stakes of bodily representation. He takes up a tradition of the description of the body in the history of painting that many readers will recall from the brilliant writings of Elie Faure and André Malraux. Deviating from standard treatments of art history, both *L'Esprit des formes* and *Les Voix du silence* contend that the task of the artist is not to "represent" the world but, rather, to *rival* with it. Documentary works tell us how the body was shown or figured, but real works of art pose impossible enigmas about the status of the body in history: the body becomes the site where the entirety of the world is reconfigured or reorganized with uncanny intensity. Malraux especially reaches back to early Christian, Romanesque, and Gothic art in order to show how representation is less an end of creation than a means to study symptoms of collective dilemmas. That, for example, in Romanesque sculpture the body is squeezed to fit into the crannies of capitals and tympana does not mean that truncated representations are equivalent to a scorn of the flesh inspired by an awe of terror or God; nor do the flowing robes of smiling maidens at Reims or Amiens, who slowly detach themselves from the jambs of Gothic portals that hold them erect, mean that the body is now perceived with a fresh and sensuous aura.

Rather, these areas become sites where the body is theorized over and across history. In the Christian tradition, as Schefer

notes at the beginning of his essay, when "figurable, it [the body] is incomprehensible and thus remains incomprehensible because it is figurable" (28). In other words, the very act of representation entails an act of displacement or even transgression (in the sense of a traversal) that carries an imaginary body into unknown spaces in order to express what cannot be stated in the lexicon of contemporary forms.[8] The task of the artist is one of turning the representation of the body into a creation of incomprehensible enigma. The latter resembles a virtually unhabitable mass—like the piles of folded and "crumpled" cloth all over Uccello's *Deluge*—that thrusts our unfigurable imagination of the body into various shapes, colors, and languages that translate recognizable meaning into sheer radiance of signification.

Throughout Schefer's study of the body we encounter a series of terms that, in the 1990s, seem to belong to an oblivion of critical theory. In the decade following the aftermath of May 1968 and the intellectual revolution of structuralism, in worlds of politics and criticism alike, cultural theorists have witnessed—like a Freudian superego—a return of meaning, of history, of documentation, of authority of fact and order. *Formes et normes, formes énormes* : disciplinary practices have retrieved methods and agendas that seek to exclude the former labors of critical theory. The latter, however, marked a moment, in France, at least, at which concepts of psychoanalysis and linguistics were mapped onto almost every field of investigation in the humanities and social sciences. Michel Foucault summed up the moment in 1970 when he announced that the task of his research over the next decade would call into question our desire for "truth"; give back to *discourse* its quality of being an *event;* and, in a note that appears to inspire Schefer, "raise, finally, the sovereignty of the signifier."[9]

In an area at the border between literature and art history *The Deluge* brings back to us the ferment of that "revolutionary" historical moment. The writing respects the power of the *signifier.* Schefer uses the term in affiliation with Roland Barthes's study of semiotics, insofar as the signifier (*signifiant*) becomes a site of analysis that melds linguistics, Marxism, and psychoanalysis. Barthes revived Ferdinand de Saussure's distinction of signifier/

signified/sign in order to investigate the ways that conventional uses of language determined how and what could be uttered and conceived in given historical contexts. He showed how all acts of speech and writing are fraught with contradiction or display confusions produced by ideology. Like Barthes, Schefer uses the signifier to indicate exactly where a context fails to control meaning, or how expression radiates beyond itself, how it collapses into paradox, or how it exceeds its limits of meaning. The signifier can tell where a work of figuration loses hold of itself and opens a space for dialogue with readers and viewers. For Schefer, Uccello's painting amounts to a great labor of the signifier and, hence, depicts a vast arena of shared phantasms that cannot be reduced to meaning. And, because psycholinguistics had shown that the unconscious is structured "like" a language, and that the signifier preempts meaning or truth, these phantasms appear to be organized according to a taxonomy. The phantasms of the signifier are related to the spatial arrangement of a Vitruvean memory-painting.

We should note that the author's identification of this painting as a work of the signifier has a political implication both at the time of its writing and today. In institutional settings analysis, creative writing, and aesthetic history work under fairly strict enforcement of meaning. But when it appeared in 1976 *The Deluge* went much further than the author's earlier writings in displaying how the author's own body was immersed in—and displaced by—those seen in the fresco. He reduced all professional distance that usually separates the subject and object in order to let the painting work through the experience of our time and to allow our world of images to seep into those of Uccello and fifteenth-century Florence.

Like Rosolato's concept of the perspectival object, for Schefer the signifier becomes the meeting ground of two cultures. The point of contact is made visible only when the writer, spectator, and reader allow themselves to be moved by the force of writing. The point is cryptically but decisively made in the first sentences of the book. The author notes how impressions of the painting inspire him to write and, by extension, how he must craft the text of his essay to make of reading a moving image of writing. The

painting literally propels our desire to see and write to the degree that we only begin to *see* when we are *writing*. The text operates like a "writing machine" that turns the reader into a writing spectator who blends into the signifying process of the painting. Thus, we find ourselves turned into what, in a different but equally appropriate context, might be called *spiritual automata,* or sensory mechanisms that produce meaning through the mechanism of memory, *ekphrasis,* and a collective need to write.[10]

As automata, if we have affinities with Schefer, we abandon institutional support and work outside of parameters that tell how and what we must communicate. The liberation from these constraints brings others of a more imperious nature. On the one hand, the writing that emerges from the dense reading of Uccello is so involved with Schefer's own memory-world that the work risks losing all common ground of exchange. Yet, since it engages a universal life of forms in art, the reader has bearings enough to navigate through the meditation. Schefer offers comparisons with Tacitus, *The Decameron,* da Vinci, Saint Augustine, and others. The writing also sustains a relation with photography and cinema, beginning by invoking the matteness of black-and-white photographic reproductions of Uccello's fresco and their tendency to emphasize scratches and scars that turn the painting into a speckled and leprous surface of desiccated plaster. The reproductions paradoxically underscore how the painting can in no way be said to "represent" the human body as it was imagined in Florence after the plague years. The cinematic dimension of the painting is likened to the great movie reel of Uccello's wind turbine and of the montage or conception of visual lap dissolves that turn legs into catachrestic table feet or billowing folds of flesh and cloth into visions of cheese that the painter is forced to eat in exchange for his labors.

More specifically, readers familiar with Schefer's great work on memory and silent cinema, *L'Homme ordinaire du cinéma* (The Ordinary Man of Cinema [1982]), which treats of monstrosity, slapstick, and comedy, will note how an iconography of movies inflects the metaphysics of the fresco. In one autobiographical moment in the essay the author reports how he returned to the cloister of Santa Maria Novella to measure the height of Dante's

body in the picture. All of a sudden, in the chiaroscuro of the church, he is struck by a "dark shaft of light" (an *éclair sombre*):

> a first film where a commotion appears, that hits me square in the face, with what had to be understood as the invention of the signifying body: something as barren as this meaningless, painful, embarassing, stubborn comedy (*Good Night Nurse*). This double chin that in the movies unwinds Fatty's face, dripping with rain, that reveals its cinematic absurdity.[11]

The Augustinian dilemma surrounding the "invention" of the Christian body slides into an image recalled from one of Fatty Arbuckle's early one-reel comedies. The history of cinema becomes part of Schefer's memory-theater, and at this moment the persisting image of the obese and disgustingly seductive human blob—Arbuckle—inspires Schefer to meditate on the body as a hilariously amorphous mass of waste set in counterpoint to the sculpted body of Dante at center stage in the painting. Something of a "cinematic absurdity" (100) tells us that we cannot fail to laugh at the painting. Since our culture has lived through the memory of film, it is impossible not to imagine the players of the fresco as comedians who flicker on a flat screen of images that shape our lives.

Yet the allusion to Arbuckle underscores the theme of monstrosity and representation of the body, insofar as its grotesque *absence* of form ("this pasty face") or likeness to unmolded cheese or lard draws it into the material with which Uccello worked (as well as what he ate), at the same time that the figure conveys a sense of wasted potentiation that marks all great literature: Arbuckle (like Joe Roberts, Oliver Hardy, Robert Middleton, Dan Seymour, Thomas Gomez—other Hollywood fatties) is a human oddity who tests the limits of anatomy. He displays the body as a series of fleshy folds. His sight inspires us to reverse the course of psychogenesis when we ask ourselves how it would feel to "inhabit" this grotesque envelope of boneless flesh. Schefer calls this phantasm "the invention of an entirely originary signifier" (100) that leads to marvel over the relation of waste to all representations of the body.[12]

Schefer disrupts traditions of description in art history and criticism by juxtaposing figuration and signification. In the for-

mer we are held to observe meaning residing within or behind a pictural form (e.g., a pitcher in a maiden's hands is a figure of her "virginity," a sign of its containment of milk or future nourishment, and its handle is the "fetish-object" that elicits our desire to hold it, and so forth). The latter, in contrast, informs of an allegorical ensemble composing a limited sum of meanings that can be readily translated from an image into a discourse. Schefer refuses to accept these notions on the grounds that (1) the instance of perception always *selects* given figures and excludes others, and (2) the need to turn figures into cohering totalities of meaning is ideologically suspect and historically determined. Limitation of meaning is dictated by traditions of religious iconography imposed by systems of belief, by pedagogical traditions, or other apparatus. Schefer breaks the closed circuit of figuration and signification by investing spatial forms with a drive of writing.

Throughout the *Scénographie* and *The Deluge* we discover that figures and signs of this limited kind emerge into view only when we allow ourselves to believe in the *illusion of spatial depth*.[13] A painting will acquire meaning if visual signs are located in what is assumed to be a three-dimensional volume. When space is accorded this illusion, movement of figuration (troping) is possible. The same holds for writing, insofar as any verbal description is said to represent a world that exists on the other side of the printed page. A field of representation resembles the illusion of a depth of field to the degree that a stable meaning can be extracted from the whole. To disrupt these perceptions Schefer uses the verbal material that informs Uccello's painting to destabilize its illusion of meaning. Writing bodies forth through visual form. Thus, as soon as a verbal register is seen inhering in the figures, their signification falls prey to all kinds of distortions that arise from movements of signs and figures within the painting and across the time and space of its viewing. Figures that are arranged in an illusion of space become part of a single lexical surface that turns them into verbal signs. These, in turn, are subject to change through the very process of analogy that made them visible.

Yet Schefer decisively alters the relation of word and image that holds in most literary and art historical domains. He shows us that perception of any *detail* in Uccello's painting betrays selec-

tive desires on the part of the spectator. The detail figures as a hinge not only between the work and its reader, but it is especially a point at which ideologically prescribed differences between figuration and signification begin to collapse. His obsessive description of details folds writing into painting. Rebus-like shapes result and yield a composite area in which we literally get lost.[14] Becoming a perspectival object in the field of the spectator's or reader's imagination, the writing also resembles a concatenation of problematic details. When selected, or instanced, the detail becomes a composite lexical and pictural form that moves between consciousness and the unconscious of history. In Uccello "here the detail is less the imagination of a texture of the painting than its puzzle, especially a kind of *flat* being" (113), in other words, a "pictogram," or a verbal fragment endowed with spatial virtue. Language thus swims in and through the figures in the panel and surfaces in the grains and cracks of paint and plaster.

Study of detail and the erasure of depth within a field of illusion appear to be two of the most effective modes of analysis that the reader can draw from *The Deluge*. With them Schefer is able to open a place for the reader to work within the play of text and image. The reader is free to place into the field of study not only the texts that Schefer cites but others as well. At stake is not a topography of quaint misreading but, rather, a site that reserves a place for readers to singularize their fantasies in dialogue with the essay. The work, in fact, invites participation of ourselves, the "other" who is partial "author" of the work. Thus, as we work through the "Scene of the Deluge," we sense how our bodies are displaced from a site in the history of terror and plague that is being made present through the writer's relation with Uccello.

Schefer's writing is not easy. The style resembles that of a mystic who performs in language a narrative of continuous epiphany described as occurring *outside* of language. To gain access to that epiphany Schefer approximates a writing of painting: in order to convey its rhythms I have tried to respect the syntactic unity of each sentence or fragment as a pictural detail. Since parataxis prevails—there being no order that leads from beginning to end—the task of the translator has involved reproducing sen-

tences as graphic (even musical) notations set in a serial configuration. The order of subject-verb-regime is less common than the musical measure of verbal "beats" that are akin to bodily throbs, which pulsate and make signifiers move through and about the mass of details.[15] Hence, no attempt has been made to bring restrictive or unnecessary continuity to the text. Following some of Rosolato's conclusions about the visible character and spatial rhythm of speech, I have tried to hold to a specific translation of recurring terms. Their obsessive presence in the text is underscored at the cost of some redundancy. Some of these, as we have noted, entail "folds," "escheating," and "crumplings" of meaning; often the term *espèce* is used to mix inherited differences between animality, corporality, taxonomy, and reason. Wherever possible I have opted for *species,* but with some interpretive variation on "type" or "kind." Wherever the prose seems balanced between bodily and rational process I have tried to convey the feel of the former inflection. In many places the prose turns into enumeration of detail that forces readers to supply connections with fragments of images from a collective store of memory. The effect is one of being at sea, the reader floating like a cork on tidal swirls of water, or being pulled in an undertow. I have tried to approach an English that approximates the same effect of drift and vortical pull that moves so much throughout this extraordinary piece of writing.

NOTES

1. Guy Rosolato, *Eléments de l'interprétation* (Paris: Gallimard, 1985); "L'Objet de perspective dans ses assises visuelles," *Nouvelle Revue de Psychanalyse* 35 (Spring 1987): 143–64; "Hystérie: névrose d'inconnu," *Topique: Revue Freudienne* 41 (1988): 19–48; "La Double potentialité de l'inconscient," *Psychanalyse à l'Université* 59 (1990): 3–12; "Comment s'isolent les signifiants de démarcation," *Topique: Revue Freudienne* 49 (1992): 65–79. In "Pictogramme et critique littéraire" (*Topique: Revue Freudienne* 46 [1990]: 269–80) I have juxtaposed Rosolato's concept of the perspectival object and Piera Aulagnier's correlative work on the pictogram to propose a common method for analysis of writing and painting. Work in the paragraphs that follow draws on their clinical experience. In all of Schefer's writ-

ing we discover that articulation is inspired by a drive to make present a complex memory of texts and images of origins.

2. It should be stressed that when Jean Louis Schefer combines figures of painting and theater he appeals to a potent body of analysis that illustrates how all production of discourse occurs within pictural or theatrical frames in which speakers and writers feel themselves surrounded. In one of the most accessible—and compelling—works of French analytical signature Joyce McDougall shows how "psychic dramas of the theaters of the mind . . . await production on the analytic stage." Analysis entails constructing psychic scenes: "The characters in them give themselves away through sudden strange associations, fantasies, slips of the tongue, or dreams, thus sliding through the conscious use of language." She adds that these same "unconscious revelations often give the analyst a glimpse of what the analysand is seeking, stumblingly, to put on stage" (*Theaters of the Mind* [New York: Brunner/Mazel, 1991], 17–18). Schefer's own work resembles that very theater; throughout we are asked to listen to it as if the slippages of the discourse were the measure of its force.

3. At least eighty-four workshops in Uccelo's Florence studied perspective and were related to intarsia, in which mathematical and geometrical models were used to produce complicated figures of polyhedrons on wooden surfaces. Uccello, an innovator in these designs that became "an intriguing instance of systematic self-reference," had executed an elaborate figure of a mazzocchio. The form was considered one of the most complex of all executions of three-dimensional forms on a flat surface. Alan Tormey and Judith Farr Tormey offer a history and an illustrated study of the mazzocchio in "Renaissance Intarsia: The Art of Geometry" (*Scientific American* 247 [July 1982]: 136–43). I am indebted to James Porter for reference to this article.

4. Frances Yates reviews the importance of Vitruvius' plan in space and intellect in *The Art of Memory* (Chicago: University of Chicago Press, 1966), 136–37, 170–71, and 363–66. The background of this study is invaluable for a full appreciation of Schefer's work.

5. Schefer's interpretation may have its clearest expression in Jacques Le Goff, "Corps et idéologie dans l'Occident médiéval" (*L'Imaginaire médiéval* [Paris: Gallimard, 1985], 123–26 and 136–43). Le Goff takes up the Christian reorganization of the pagan cosmos in "Cul-

ture cléricale et traditions folkloriques dans la civilisation mérovin-gienne" (*Pour un autre moyen âge* [Paris: Gallimard, 1977], 223–35).

6. The tenor of Schefer's descriptions of illumination and passage is mystical and shares much with a taxonomy of writings that Michel de Certeau studies in *The Mystic Fable* (trans. Michael Smith [Chicago: University of Chicago Press, 1992]).

7. At these points the work recalls Gilles Deleuze's argument that the *fold* constitutes the Baroque experience par excellence. Although Leibniz conceptualizes the movement and form of the fold in his theories of the monad, the figure is used to study the European philo-sophical horizon from the fifteenth century up to our day (*The Fold: Leibniz and the Baroque* [Minneapolis: University of Minnesota Press, 1992]).

8. In his relation with Uccello, Schefer performs what Michel de Certeau theorizes about the ideology of history: the past is always a fictive invention that is brought forward to mediate what cannot be stated in the present ("The Historiographical Operation," *The Writing of History* [reprint; New York: Columbia University Press, 1992], chap. 2).

9. *L'Ordre du discours* (Paris: Gallimard, 1970), 53.

10. Roland Barthes had thus hypothesized that the verb *to write* can be intransitive. In turn, Réda Bensmaia has shown that contem-porary writers work from the standpoint of *catemnesis* (as opposed to anamnesis), or a continuous drive to write out of the present (*The Barthes Effect* [Minneapolis: University of Minnesota Press, 1987], 164). Catemnesis appears to be the figure that best represents the "writing machine" that Gilles Deleuze and the late Félix Guattari in-voke in their work on spiritual automata, in *Mille plateaux* (Paris: Minuit, 1980), *Qu'est-ce que la philosophie?* (Paris: Minuit, 1991), and elswhere. In an unpublished essay on Montaigne entitled "The Fru-ition of Loss through Memory" Tilde Sankovitch aptly calls anam-nesis "the morose and static recollection of the past" and catemnesis "the continuing creation of a text always springing from the present."

11. Jean Louis Schefer, "Fatty," *L'Homme ordinaire du cinéma* (Paris: Gallimard/Cahiers du cinéma, 1982), 100–101 (hereafter cited paren-thetically in the text).

12. In a review of *L'Homme ordinaire du cinéma* ("Reading Ordinary Viewing," *Diacritics* 15 [Spring 1985]: 4–14), I have tried to examine

how the grotesque figure in silent cinema has a *de-monstrative* virtue that gains appeal not through any horrible image of dismemberment but by eliciting a stubborn, funny feeling of pleasure and disgust running through our bodies and our memory of time passed (or wasted) in movie theaters.

13. *Scénographie*, 103 and passim; *The Deluge, The Plague* 113–14

14. This same loss of space and place in the writing is what Michel de Certeau describes as "*un lieu pour se perdre*" [a space in which to get lost] in his study of Bosch's *Garden of Earthly Delights* (in *Mystic Fable*, chap. 2).

15. In *L'Espèce de chose mélancolie* Schefer states that a "book" is less an object than a "series of lines that float, insinuate in the middle of discontinuous notations" and that he "works according to the metronome," which is identified—yes—as the second arch of Uccello's *Déluge* (229).

ABOUT UCCELLO'S
UNIVERSAL DELUGE

The relation of a work of writing, or of writing to painting, entails a relation of initiation: painting inspires writing. Bataille represents thus this destructible relation: "the painting erases the work of writing." We can be sensitive to this position that *turns* about bodies of memory and grasps their points of convexion.

Should we wish to know how something becomes immobilized, in an insistent and mysterious way outside of writing, we would have to inquire of the tradition of the memory-arts in Lulli, in Giordano Bruno, and in this continuous art of scanning, from Greece and Rome, that accompanies the growth and construction of the figurative field. Notably, in order to observe how the question of content is first of all ruled, and then absorbed, by the techniques of memorization: we recall the invention of *memory-places*. The way the real is punctuated by ghosts might shed light on the problem of a fragmented subject of history that is parceled into symbolic units, or constructed like a fugue on diverging fields. That, perhaps, is also where the problem of figuration is placed: historically, figuration would have constituted an "order," to the point of composing an instance that might absorb or cause to bifurcate all cultural production (the catalog of sciences) in a *general field,* to the point of annulling (making indistinguishable) the individual disciplines within. At stake is a partial but, to be sure, determining aspect outside of which figuration would massively resist historical explanation. It would be monstrous and restricted to a rather narrow aesthetic domain. If painting traditionally touched all edges of culture, it was not in order to be a more exclusive practice, but probably in order to redirect, in the most insistent and perhaps most blinding way, a series of cultural elements in what they were held to be most mysterious. And that

in a space that is increasingly subject to this pressure exerted at the edges. We can see the extension of a network of symptoms in the emphasis placed on the return of the "figure" precisely when the integration of the problematic status of the subject, at the moment when its "formulation" was impossible. That would indicate neither an exponential function of figurative painting upon the total configuration of this discipline nor its reduction to a function of expression in the structure of this discipline: but, rather, to a probability of overexposure to determining factors (to "contents") that ground the figurative discipline, its field, and its order. Through the effect of a kind of porosity in which the mysterious rise of the signifier is recognized in the field of painting.

≋

The system of figuration appears as an immense grid controlling unknown entities (touching on determinations: space, forms, colors) that does not constitute a system of their resolution: these elements figure in it as unknowns. It thus posits the enigma of an inhumation of the intelligible body; of something that must, but cannot, be understood as such.

≋

Uccello's fresco presents, or, rather, *rules over,* a state of the body in disaggregation (unclothed, blurred, sunken, set in a liquid magma, truncated; in one respect, these states of the body can be attributed to a fiction of positions and conditions of Uccello's vision), submitted to various degrees of erasure, of rubbing: and that would also teach us something about a unique position in the history, or in what might be called the system of an evolution, of figuration.

This scene stages an *erasure* of the labor of anatomy: an effect of an unpiling and of a pleating of linens that appears to slip into figuration the revelation of a kind of bodily terror (the body is caught in a circuit that goes from a gentility, or politeness, garbed in curled fabric to the body's bestiality; it is an arc in which the painting suspends the body between the fantasy of a prehistorical body and a Florentine costume). The catalog of species merely exhibits a variation on the erasure of anatomy: that of its literal

reification, its mixing in a new—liquid, chalky—medium (the bodies seemingly at once petrified by and mired in the matter *they never expected,* and through the erosion of colors here bring forth an implacable matter, as well as their *matteness;* they are overtaken by a constant impoverishment of this painting. An erosion very much like the boring out of matter that comes with the plague, and which Scipio Nasica feared might lead all the bodies into the theater).

Through an effect of anacoluthon in the history of figuration, the body is caught in a subsemic variation; the effect of rupture, or the character of "modernity," resides where it is not a moralized body (it is somewhat like the literal thickening of paint, getting caught short of moral meanings, iconographical or coded distinctions that isolate and mark a sort of sacred instance in all figuration upon its religious or allegorical share). Here the body "emerges" into space.

An obvious threshold: here the body, at once in a state of birth and of putrefaction, *does not congeal into* painting that is contemporary to it. With the same contrastive effect, or of rejection, we have the *mazzocchio,* in other words, the empty "allegorical" figure, that is immobilized as an intentionally technical product of a figure's definition.

Something quite close to manipulation is taking place here, possibly the invention of a new matter, of the mythical signifier (but not mythological figures by which classical art has been defined from Lessing to Winkelmann), of a color that continuously makes an impact, as a thread of reading, in Vico's writing: pale ochre, reddish browns and their gradations; Vico, whom Joyce stunningly recalls, notes that every age ends abruptly, theatrically, with a storm, in the *fear of thunder.* That is also why this absolutely unheard-of manipulation of the mythic signifier embroiders, all the way up to this paradoxical conscience of the night crossed, navigated, through a multitude of rivers (Styx, Lethe, Acheron), where there, too, as in *Finnegans Wake,* is a very long bodily reincarnation of this new signifier: it appears to *make porous,* or porosify, this little abode of reason and to bring it forth like an immense limit of meaning (paradoxically, here this literal signifier rides above all the commotion over a loss of meaning: in

a reactive sense, it also materializes the residue of allegorical and symbolic functions in painting of the same historical period).

Next to this effect of bodily "palpation," we would have to see in the history of classical figuration, in these instances of scenic protocol, its sacred imminence: it is extracted from a sacral cloth to which it never returns in order to mark its oblivion, or the motive of repression. The question perhaps entails less an immediate religious determination (that would reduce meaning to a strictly analogical operation in religious painting) than a sacred determination; in the sense in which figural painting is imposed, for example at Pompeii, as a formal liberation in the theater and in order to take—but not merely "figure"—the place of the *sacred* body. We would have to say that figurative painting is not born simply for the purpose of representing the body but in order to endow it with meaning in another space, the space that in every event is where the body does not dwell, a space that makes the body enigmatic. In this way, at the time of a domination or a construction of religious ideologies, a certain rise of the corporal figure begins with a very extensive bodily reversion or escheating: simply because it becomes dialectically unthinkable, or that for several centuries its thought is that of stress seemingly inherent to figuration: that an *uninhabitable* body is at stake. It is destined to the very distant place of another guilty body; it is rejected like the soul of geometry. The execrated body, a victim, now only needs to be painted; no longer sanctified, the guilty body is put on trial. Figurable, it is incomprehensible and thus remains equally incomprehensible because it is figurable.

It may be that painting, as a stasis of nondiscursivity that produces meaning (as an apparition of *the enigma held in respect to the incomprehensible signifier,* and incomprehensible by virtue of the very effect of this stasis), plays a role in the production of a *position* of the figure's denial, as the level of a *stress of realization.* In comparison, there is a strongly marked contrastive function in Uccello's fresco, of the play of referential dispersion of this signifier that the mazzocchio makes both evident and incomprehensible: in a certain sense it is impossible to analyze this fresco in

the way one works on a totally meaningful, or signifying, body, simply because a figure is included that the whole cannot integrate among its parts. It is a figure of exception that in itself causes the paradoxical system to function. Thus it is not the painting that contains an array of objects; rather, several ages of painting are working coextensively within the fresco.

≋

This Deluge by Uccello therefore holds to the enigma of meaning that it puts forward. Its status of figuration is quite complex. The problem of space and perspectival construction is oddly anachronous in respect to the figural solution being offered here: a vast metonymy of the states of movement in a stereoscopic space; the figure, understood thus as a body, is exceeded by an unknown referential and practical element in the mazzocchio. Yet, on the other hand, color is suspended in a general spatial program (here we see a *seeping*, or deepening, of color; color, it appears, is seeping into the narrative). In this respect we would have to study the strange relation established with negation—and I do not see how it can be stated otherwise—that is shared among the figures and the colors: a negation that evidently always has to be translated into a problem that, in its prospective form, broadly covers the description of figurative functions—in the first place the mode of integrating the elements into a whole and the different functions assumed in relation to the presupposition about the homogenity of this whole.

≋

Here this difference, or condition of heterogeneity, in respect to the figural bodies is taken up to the point of their arrangement. Color divides smaller units (in a provisionally morphemic type), but not details. Color is made with a thicker texture than the bodies. It works on the conditions of body-matter from which the general illumination of the entire space unfolds. We have the problem of the figurative diversification of a rarefied state of matter that is almost held in latency, or "held by a brake." One of the most constrictive levels of the reading of the painting probably engages a labor that casts upon the work a ghost-like shadow of

the body of mythology, but not of its figures. Here color would be regularly swallowed up in this layer of a fiction of prehistoric memory.

This Deluge of Uccello might inspire us to "move" in the direction of the expression of this inversion in improportionality of colors. According to the very particular commotion that painting awakens, the labor—produced, accomplished, and staged here—is what sends a process back to its imaginary cause *as* meaning; from which, in turn, the figurative system is found "caught" (this return very strongly "indicates" a crisscrossing of "cultural structures": at this point, too, the issue of meaning is set forth and thus seen anew).

At the same time it is quite astonishing (almost uncanny) to see in this fresco the figure of an effect of historical isolation that to this degree is *not moralized:* neither sacred nor profane, but merely exposed to what appears, so strikingly, to be a pagan maturity (the return of Vico).

Hence the period fascinates me because the status of figuration cannot be solved by analogically expressive functions (according to the reduction in view of a specifically figurative practice that, later, iconology attempts to perform); the figurative system being set in play is also that of a nonfiguring mass that remains blind, without name or destiny, and whose "ideal" structure, the sum of the figurative field, *does not add up.* Predictably, the figurative systems that retain our attention are also based upon what was *blinded* for the classical age. Figuration would be based (thus established and constituted "symptomatically") on an order of intrication: this limit-order—what equally goes to the edge of all deployment of the speculative field—is based on a conflagration of knowledge (of *all* forms of knowledge, including that of the body, of memory, of sexuality) upon what is introduced as an ethics of representation: all systematic explanation of the world occupied by a commutable center (earth, sun, God, an eponymous individual human being insofar as it does not refer to a species) but ultimate, in other words, through the assurance of a condition or a last actor in respect to which there would exist no process that confuses meaning: every stage of a process (thought of as an evolution) therein being studied as an explicit stasis.

Thus in this field speech and stage give way to auxiliary appa-
ratus as general mechanisms that are coextensive or animating
forces in a broader field. The labor of painting is placed within in
order to be confirmed and to be denied. We have an ideology of
science in painting, a coding of its practice—in the debate over
the "legitimate construction"—over a configuration *through the
presupposition of a general field* of figurability: perspective as the
possibility of a bridge extending toward the applied sciences in
order to reach a commutability of the very subject of painting.
About this subject, Leonardo declares that, insofar as a form of
knowledge runs through him in this arc of painting, he is a dis-
ciple of experience but that this experience cannot be stated be-
cause it is above all a knowledge gained through analogy; and
that the subject is what orchestrates an experimental or experien-
tial concatenation; and if, surely, it can come to life in its symp-
tom, it is because priority dictates that the symptom must refer
back to the system (to the configurations) that knows nothing of
the subject. Figurative painting would thus be engaged in a prac-
tice, a know-how, *and* in a presupposition of a field along which it
at least touches a common boundary in the history *of* science: it
thus might be logical that in a figurative whole—a highly en-
tropic sytem—the signifier is so clearly divided. Therefore, in
this very complex space the problem would entail grasping the
status of figuration. Moreover, it is a perfect historical object
since we have to recognize exactly *when* it transfuses into all lev-
els of depth in a culture.

≋

Uccello's fresco is an especially favored object because it is, in this
question, the support of a crisis (an obvious parenthesis in the
history of painting—it is difficult to ascertain what paintings
would be contemporary to the Deluge); I also believe that fic-
tional devices are very much invested in the work: their relief also
"stupefies" the painting, retaining the power to put forward a kind
of matteness of the signifier. These "devices" function in a way
that animates the work (the painting sets the text in motion, "pur-
sues" the text, displaces its points of attachment, its relief). Even
in a "reconstruction" of figurative epistemology, it is a type of

animating mechanism that does not grant the painting the power to totalize fields of knowledge. Rather, it would be totalizing in the method of memory in order to affirm that something is no longer there and that there remains only *a kind of bias that no longer bears resemblance.*

≋

This can therefore, in a very schematic way, define the function of the "figurative body." (Not merely of the "character" but of every figure insofar as each retains the *memory of a position,* of a resolution, in symbolism, in allegory, and the like, because within it painting produces the effect of this return upon which bodies possess a memory, specifically that of a signifier's *ductility.* The painting *gazes at this bridge.*)

≋

What is hence conduced in the writing is obviously the problem of retinal persistence of something that, in the painting *in which one is writing,* bridges, but without it being made clear that this bridge is leading in any given direction. It would thus lead to its abrupt rupture. The bridge leads to a disturbed and historically overplotted memory of the signifier, namely, that of knowing precisely where it moves and upon what bodies. The obstinate, enigmatic signifier is also the map whose shattering cuts into the destruction of suspense that held it together, and cuts into additional articulations, and their particular theater: everything through which the painting is crossing; the certitude that the painting retains for itself a barrier of fiction over and through which it crosses. The ferment, the rennet of a relation that, up to that moment, had been unwritten in language.

Here, then, is where a fiction enters that happens to *finger* the bodies of the painting (where, for instance, the *plague* enters Uccello's Deluge).

≋

To write about painting is therefore, *first of all, to write.* It also involves noting (as in music) the *variable* distance that one holds with the painting.

In a language there are several idioms. Likewise, in a textual creation several writings are working together at the same time.

The book is thus only constructed gradually from textual fragments (these are still pieces of the fresco seen either from afar or in close-up: such as the animals of the Deluge). Therefore, in several movements the body of the fresco will be "tacked up," unshattered.

The text is also another labor of color (color here being something like a body *twisted out of position*).

If we are to undertake *a return* to historical objects (an object of unknown structure)—at once reconstituting and ascending it— the enterprise is also produced in the order of an imaginary causality: on the *effectuation* of such an object, its signifying share, its equipollence (in both heraldic and geometrical senses) with the text.

The bridge that the painting envisions is built over nothing but aligns a body (almost any body) with the signifier: in its sense of direction. The bridge and the fear of a void in meaning. Writing is never either entirely protected from nor assured of not disappearing into it. This is, indeed, Uccello's bridge, the bridge of the symptom (beginning with an enigmatic body).

The painting (this fresco) will have therefore sustained a passage but also a construction of a piece of writing. But writing does not (always) go in the direction in which we might believe it may be dwelling, enduring, *and* disappearing.

Where a rhythm disappears: a kind of absolutely disproportionate fear that inhumes whoever is writing. That replaces an arhythmic nothing with the cremation of every object in memory. On what might be a pronged body busy at scribbling words.

THE SCENE OF THE DELUGE

THE GRID

The frame that isolates the photograph is not that of the painting. Neither canvas nor gridding exists behind the fresco. The structuring is the transcription, made through the development of a black-and-white picture, from the typographic code of color. From this double conversion of color into black, there becomes visible, as the obviously constitutive aspect of the material of painting, a labor of sifting, filtering, of encoding: the new code extends a "net" that captures the imaginary texture of the "detail" in the minute workings of its webbing. As if a new code were being stretched over the substructure of the fiction; this is not painting but a double coding that seeks to *cross through* the painting by constituting a distinctive function of its reproduction, an embryonic, or *meristematic,* level of detail.

But it is also because no "good" reproduction of the painting is available. In all of the photographic copies color appears to bear a degree of fading of a general texture; the color is bound to a thickness. Paradoxically, the painting (what meristematic growth takes up in the fiction) is in its turn translated into distended linkages: to the left, branches, leaves, droplets of water; the metonymic suspension of the painting to the right, traces (brown) of the paintbrush applied to the wooden panel. Facing in front, as an image, the ceaseless division that makes up the movements of the painting.

THE PARADIGM

Fissures, flakes, depressed bodies: the trapezoid of vanishing points is not the site of a yet undivided germination but the final condition of figures crushed and of painting defected. (But that is the point, scattered, whence the taxonomy of figures and colors

35

might begin: however, division also speaks of the enamel of painting in a fiction.)

In the background of the painting (it is a fresco), at the bottom of a tomb, is a stain of soot, a delicate mark of a gummed eraser on a soft pencil, up to and at the point where the colors begin to ooze. The body, cut in two—black and white, back and front—is moving, each part like a fraction of an image, toward the limit of its arc (black and white).

ERODINGS

The eroded detail on a given photograph allows different planes to interact: the space of the fiction is not a space that has been cleaned: once the bodies are removed, the decor remains, that is, the program of a single color (chestnut brown); according to its symbolic prescription, the chestnut decor (the dejected space of the bodies) is the funnel, the fecal shell that contains these "roles": *inter urinas et faeces nascimur.*

That is why the painting plays on a unique stage (contrary to the fiction that tends to divide it); overlapping, these are two narrative acts, bodies that appear divided on a single stage. In place of the double stage, on the two arches that face each other, are two tipped panels, without a mirror, whose silvering has turned brown. They effectively reflect only the refracted rays con-stituting the roof of this space (the rays would only bounce back to a roof, a webbing, or a net of the fiction; in order to fish for what species of fish? a bath of tannic acid out of which bodies emerge . . .). They read only the back-to-back and the division of the characters. The color of the mirror: its water is what has flowed to the ground like the liquid base of the painting (a sink-ing, a drowning, a bath of mercury or tanning fluids). What the painting offers in the chestnut tain of the wooden panel is the other side of the mirror. Like its function, the color of the mirror is, justly, the fiction of all the bodies of the painting, akin to mo-ments (scattered limbs, truncated, petrified bodies, bodies split in two: the entire vocabulary of the Freudian uncanny) of a color.

≋

Here the painting states what it is doing (each panel inaugurates the pictural agenda); nothing can properly be said—touching on

a piece of writing, a fiction that always states its law—of the painting. Nothing has been justly written, or argued, about the so-called perspective before the defeat and denial that this painting always envelops; this text, but this white wall, is whitewashed, and, because of the effect of what is painted over it, the wall appears leprous, kept alive by the very disease that pocks its surface. With this flaky wall we have to see how the painting explains, designates, recounts—so fabulously—its illness. But not in the following manner: "Before us are the figures that simulate something about the real (thus what?)," that furthermore would neither be touched nor gazed at but would be withdrawn (here at least) from the putrid swell of water, withdrawn from the stench of stale piss, from the wooden panel—the floating house—daubed with shit applied in broad brushstrokes. The labor of simulation, or labor itself, that of the wickered mannequin in which a cadaver is enclosed prior to its incineration. Because neither representation nor ceremony amounts to anything else; the urn has to be opened again, and we have to plunge down to the resinous bottom, to the black gum, to the embalmer's tar. To know only one thing: how the whole painting, the painting in its entirety, plays only one game, its stakes with death, the goal being how to bring it forth, how to inflate it beneath its skin; but here, in the perspective, in the multiplication of figures, the painting mimes an unstable, disquieting death, a death that endlessly comes and goes, back and forth. But on what ground is it playing? about what, with what fiction, does it gather its support?

Et in Arcadia ego. But who is speaking?

Here the painting says this—and it is not a discourse—to undo the classification, the order, the theory of elements; it mixes them, loses them, endlessly grinds them down, multiplies them. Look how they are spread out and mixed together. And of what pictural plane are you speaking? All the planes are vanishing, and that is the very space in which the elements lose all sense of place. The effect of fiction blows them away (someone in the fresco, a woman assiduously spits a jet of water, she spits anywhere, on a dog). Fiction is the depth of what is being produced everywhere,

all over, on a single plane. The drowning, the disruption, the floating, the bobbing: these figures bring the painting forward. They also take it away.

But another time is needed, and it needs to be resolved. We also have to know how to enter and to close all the doors behind us, how to saturate the symbolic entry of the signifier.

It would not be said that the stakes are important. Whoever goes about the task cannot proceed without measuring the effects of anxiety that already informs the discourse being written, of being able to say nothing that does not measure the impertinence of a juridiction of meaning, of laws, of causes, of cavities. And of pleasure that does not go for nothing in this business and that must surely divert us from the desire to speak correctly about the painting.

Probably not because there is nothing to say but because, all the same, there is (does something other inspire writing?) the call of an unlocatable signifying strategy, like a *promised power* of a shift in places, of the design from which something could be stated. To stick to the very power of this concentrated force, which is braked and which, like a sheet of ice, sends writing "out of control."

Thus, we might pretend, for a moment, to be inside the painting.

And in order to work our way through the murky depths, we have to see how it is spread all over, like a paste. The deepening of what was in every instance glazed; perspective (but there are hardly any plurals either here or in theory) is also a staging of symbolic liberation. That the history of painting (Cézanne) may have caused to appear, in a movement of truth, the ideologically suturing effect of perspective (that still believes in that time or that history?) carries away scarcely anything more than the (technical) truth whose opening it promises and whose course it leaves to another historical time (because it also inaugurates a diversification of chronic periods of symbolic law; all the historical regressions merely inscribe other times in their "before," and only a "little dose of Marxism" would occult it). Yet behind it, behind the problem of this new, inaugurated time, the painting that remains entire to itself, not read, continues to swell. Until

(here) its crust begins to crack. Now is the time to read it. Afterward, and for an indefinite period, time will remain for another evaluation.

It might be wise to note the importance of Uccello's place in the history of painting. This would be an undeniable beginning (but no sooner, also impossible), the initial writing of this essay. But, as we shall soon be noting, the history has to be written in respect to the text that we are reading and only at the point where we are reading it. The Deluge: since, too, the painting takes up history itself, its beginning (because it is always the fictive connection of history, the history of painting), that works through the Deluge once again, but less of its representation than its conversion (a symbolic, fictive, simulated conversion? Painting states, "such are the depths that must be painted").

But here history is detached and surveils nothing. Like anything else, it is disengaged, torn away, adrift, in sum, left to work on the foreign body that is simulating the effects of history. History works in a certain respect only for its own ends, on its own account (we can also say, "for itself") on a stage whose precipitation, summary accounts, ruptures, and unlocalizable effects of discourse it is explaining. Where everything from the discourse that would appear linked, classified, hierarchized, figured in a repetition of time (but aren't we finding here, in the figures of fiction, in their theatrical anachronism—the acting of bit players—a living, less historical space, stuck, glued, pegged to a very old backdrop, that of time, that which comes before the Alliance, before the fabulous inauguration of the sign?) might be affected by orders that would assign it (and first of all to linkages, to oppositions) to a "figure" of writing: that of a violent unbinding or unhinging.

FIGURE: THE PARADIGM

But in the background of the fresco a tree is bent over, torn off through the effect of a gust of air from a fan in a giant wind tunnel. Turning in slow motion, its blades detach areas of cloud, earth, and forest. The phased deceleration of the propellers describes a disjunction of species (and if these slowly moving blades are in the cutting areas producing nothing more than a

39

redistribution of spaces along the groins of color?), a tree bent over, arched to the point of being uprooted (these are the branches thrust very quickly against the boards of the arc and that slip, hook on, slow down, and *decompose* to the point of duplication, to the point of putrefying the body that sticks to it in order to advance, in an opposite direction, *against the wind:* in a slow navigation toward the background of the painting. If it gets there, when it appears to touch it, the body will be squashed in two and, with a theatrical gesture [as they say, in the manner of Poussin], sliced in two, in two men, in two movements, in two colors. But right there, separated by the figure emblematic of the entire disruption, the two bodies are disjoined, as if by a paradigmatic bar, by the tree that is being blown over).

Never before has the background of a painting been elaborated to such a degree. The background—not the curtain, the wall, nor the *frons scaenae*—but the tipped plan that carries the figures, the processions, the landscapes; here the ground itself (marble, earth, grass, a floor) is a lagoon, a swamp, a basin inundated with layers of earth, floating objects, bodies, bodies that are stuck into the scene like corks in a bottle.

The background of the painting, its ground hardened, cultivated, blindly spins away, in a great lost gesture.

How can one measure, survey, draw one's bearings in this moving water? The scale of proportions (what yields a receding perspective) floats along the length of the arc on the muddy surface of the painting; and might not the history of color be, first of all, this putrid depth in which all the bodies of the painting are placed and that, paradoxically, upholds the cutting, tipping angles of the navigation? What is flowing below the figures and endlessly lifting them away?

Along the edges of the fresco (inscribed in this "lens"), right where the picture only has sides or fringes that continually detach it from the painting, the fake frame clasping the water, the two uprights in perspective jamming the scene (but causing it to shatter when they close upon it), prolonged by two panels on the right and left that flow over the double scene of the Deluge in perspective and that here and there constitute the perspectival aperture in two initial planes, akin to a new background in the

painting (and here the painting is on a wooden base, the figuration of its old depth is in *affresco,* the *tavola*); the fresco flows over, widens, takes up the scene of painting.

Never before has the background of a painting been elaborated to such a degree, and probably never before, on the prop of a fiction, has it been subjected to so much symbolic pressure. And it is because the fiction in this painting is not to be resolved, as would a logical proposition: to the point of evidence the fiction constitutes the progressive stages of the labor of painting itself, the apparatus that informs painting and that holds only to its paradoxical, unstable position, but that attests to a loss of the referent: here the signifier works akin to the fiction of *what* is being represented. The interest of painted narratives is literally the sole, ongoing, endless edification of their elaboration. And in Uccello this works on two occasions, in the *Deluge* and in the *Profanation of the Eucharist.* Behind or within painting itself, like the additional transparency of its laws of meaning, what is being touched is a law, a ritualized representation of the sacred in history. What the painting is staging (losing its narrative in one swarming gesture, in other words, the threatening power of a sequence of events); what it precipitates (chemically) is always a piece of the sacred. What it moves, stirs up, and works through are the sacra, the players of biblical history, the sacred institution as contracted models of the species of the sign. In the *Profanation* it is the Eucharist that travels in a space of anxiety about ritual motives (Christian, Jewish, Roman) whose eucharistic sign is never money, that it cannot squeeze all together and into the stratification from which it is loosened, is liquified, and flows away. This semioclasm that is being accomplished on its own takes place because the painting becomes the background that corrodes species, equivalences, and is precisely what gives, releases, produces, signifying matter (in the first instance, of the color red). To the point where the signifier is the *unexpected* element of the representative system (of what, most notably, perspective and the vanishment of lines had already established in sketches: in this same fashion Leonardo's writings on painting— and on the excess of science that circumscribes painting and makes it the differential and negative object of a piece of writing

in a process of outgrowth and diversification—is a vain text: it is because he instantly defers the capture of meaning); the signifier is probably the uncalculated eruption (hence unexpected) of what produces the fiction. In one movement and massive thrust of delineation the fiction designates the very space that it is founding. What constitutes it in its particularity is its remaining a captive and commanding part of the space that it is constructing.

> Venice: sewage splashed onto walls, in the air
> a body having trembled here, rises out of its barrel.

THE TEMPEST

Hic summo in fluctu pendent; his unda dehiscens
Terram inter fluctus aperit; furit aestus arenis
. . . ast illam ter fluctus ibidem
Torquet agens circum et rapidus vorat aequore vertex.
Apparent rari nantes in gurgite vasto,

but already, in the injunction,

Aut age diversos et disjice corpora ponto

Be aware, Eolus, that in the scattered bodies of the tempest (and why did the Greeks call the sea a *bridge*?) only one body is concealed, that of its painting.

(Bellini: *Noah's Cloak*. The conlocution around this dead, deposed body, wilted in its white flesh, where everyone's eyes take offense at this tender, soft, pallid gum. A stage, with its sagging floor, appears elastic under the weight of everyone's gaze. Sunken, soft-posed. Around Noah the biblical hemisphere and this flesh of boiled fish: also an appeal to writing, to the pale chunkiness of a text to be pummeled, pierced, transcribed. *This* loss of the text must be translated.)

THE WIND OF PAINTING
(The art of painting / feigning); of the active real negated.

"How can the wind be painted," Leonardo asks

> / In representing wind, besides the bending of the boughs and
> the reversing of their leaves towards the quarter whence the

wind comes, you should also represent them amid clouds of fine dust mingled with the troubled air. (*The Notebooks of Leonardo da Vinci*, vol. 1, ed. Jean Paul Richter [New York: Dover, 1970], sec. 470, 236)

After the formula, however, the very question itself returns: "How can the wind be painted?" and, especially, how can painting be painted (*and how can wind be written?*). But already:

Is not what the reply suppresses, the formula, simply in the painting itself, the cause that originates its effects? What its gesture, in the objects that it is dispersing, produces: its root, its tenor, the seed borne until it sprouts; all the figures of deracination, of decision, of division, of taxonomic loss (loss of a species or kind of model, of an undivided, undiverted object, not adrift, but taken here in a displacement, a sundering that is *already* happening: of a text hemmed on the anteriority, on the already of a cutting groin of peril) like textual figures attached through the working of space (categorization, it appears, of the figures of fiction like "caches" of a production set indefectibly on the figures that it crosses through, and whose obverse side it constitutes: here, in a semantic declension and toppling, this obverse side is already cut, propelling pieces of imaged bodies: the visible body itself, of its labor as an effective negation of an originary real). And playing on the displacement, literally on the beginning through the crossing (from the beginning through the labor) of a negation of the real as the improbable origin (outside of the sequence, of the series undertaken, from the volume of shifts and movements that are already taking place): the fiction of painting is gripped (what? is said of this swirling space? a text, grudgingly, is unwoven) from a symbolic disinvestment in the real (and most of all from its respondent insofar as it is not the response of a death forever inaugurated upon the species—the rhetorical species—of a discourse). It is brought forth from this very lifting, or lightening, and this paradoxical labor of an anteriority already divided, of an anteriority mechanically reproduced from the object that the fiction sustains from the painting that speaks about its figures. This allegiance to the quiddity of painted objects is only the ebb and flow of a labor that is designated by *a negation of a positive real*. On the reminder of what the simulacrum envelops

so ceremoniously: not a consistent, isolated, detached core that is then grasped by its infinite graftings, pulverizing, traveling, borne elsewhere, and, with a return of the referent, to its withdrawal. But of the simulacrum, an obstinately senseless labor of the enclosure of the body; of an already defunct body, enclosed in the mannequin, from what and where it has already emerged (*decessus*), already disinvested, and that it is totally unable to summarize, and that remains "held" in a form (of the tailor, of the fashion designer) who does not guarantee meaning in the function, in the fiction, in the shifted, displaced translation, and inscribes the meaning only through its decomposition. As a labor, fiction is the transitive, paradoxical painting (the application) of a negation of the real.

It is *the labor in* what fiction *represents* of (of a kind of signifier that is returning: coming back for the first time) *the other side*. Painting is the labor insofar as it remains hanging (taken in dependence, enclosed) from its negativity.

But of a negation of the real (transitive, transcribed inasmuch as it states the laws, the moments—like so many personifications—of the erasure, the dephasing, of the enclosure of the referent) that does not affect the ever-pregnant indexicality, forever inscribed in a minimal pertinence. Where we would have to see that the site of the referent is the displacement of its death in the body of the system. Without any other kind of signifier. The signifier is nothing other than what transpires, rubbing at the insistence of a negation of the real, being resolved in the labor of annulation.

But the law, of the other side, of the vanishment, of the defection of functions, is forever that of history-coming-back-to-the-scene on the empty space that it is elaborating, that it brings forth, that it kneads like dough and cakes of yeast that it cracks, fissures, and bakes again and again. The lessening of the real, its buckling, has gained access to the space of historic volume.

But with Leonardo that is already written in a code of ethics that appears to hold, to articulate, tactically to dispose the subject of all new science as nothing more than the painter's precepts. Whose argumentation pulverizes the before and the after, the very improbability essential to painting. Like the phasing of its

active denial, a text prescribed in a twisted position of annulation: that of realistic effects (and this conquering assurance: "we control the ways effects are made"). At this point Leonardo's pages stand on the grounds of their probability only through the first historical reading they would make of Uccello's text. And as far as their fragmentary, lacunary state at the end of a long compilation of a text that is endlessly disjoined between the painter's precepts and prophecies (wily descriptions, a catemnesis of the discourse of its title). And that it also insists, prior to and outside of painting, but of a movement that ceaselessly envisages its end, the effect in a defection of causes, on this power of splaying out, of diversion, of the spatialization of the text that has no bearings in respect to its economy. Or, rather, without any bearings set on its economy in respect to the metaphor that seizes it: text, fabric, webbing. What we hear or understand of the text also constitutes its music: tessitura, braiding, weaving of all its voices; and what makes it take—mirrored, in a trap—is the laxity of all its figures (and, first of all, its amphibole): its figures are men surging forth, sinking into a labor of needlework, into a fish's work while fishing, that here constitutes quite specifically the gesture of a color flowing out of the figure: the textual body is saturated in a single arc of white-green-soot and deposits the brown-chestnut-black outside of its proportion. In an already bound chain that refills, nourishes itself, that diverts to bring the whole painting together: man is an aquatic beast, a putrid body (decomposed, in slow motion, phased in his place, in his color; in his movement, his body is an appeal to theater), the man is a body of soot, a shadowy animal, a species of tree, a cloud. From the sky, at the point of the overview of the fresco (vanishing points), a division of the bodies of painting is produced in the separation, in the taxonomy of clouds and colors. Here the cloud is the initial symbolic taxonomic unit (the end, the collision, the soft abutment of the painting) from which are held, as the agents of a color, the painting's indexical bodies.

> It is an easy matter for men to acquire universality, for all terrestrial animals resemble each other. . . . But then there are aquatic animals which are of great variety; I will not try to convince the painter that there is any rule for them for they are of infinite variety. [*Notebooks*, vol. 1, sec. 505, 252–53])

45

From this classification of clouds (clouds of color, heimatikè néphélè [Aristotle], a fog of color) the division out of which the fresco develops, on its background in sections quartered through the ochre of a lightning bolt, through the ochre of the mountains, to the forest, to the earth, this separation of the mist on a roulette wheel, a text is tipped into the scenery, rotating on layers of cotton that are porous, stained according to their density.

Floating, drowning, veneering, sinking: figures of writing affected by several bodies in the warped, broken, parabola of an arc of color.

Spiritus ore foras taetrum uoluebat odorem
rancida quo perolent proiecta cadavera ritu

THE PLAGUE OF ATHENS: I

(Why, Aristotle, do we visit cadavers?)
Out of its mouth the voice rolled its vile stench
the same that cadavers emit when, decayed, they are tossed on
 the ground.
(and in the anagrammatical mannequin:
out of their mouths they send up swirls of stench
the first voice of the body thrown down. [*Lucretius*])

Nil adeo posses cuiquam leue tenueque membris
uertere in utilitatem, at uentum et frigora semper.
In fluuios partim gelidos ardentia morbo
membra dabant nudum iaciente corpus in undas,

. . .

Multi praecipites lymphis putealibus alte
inciderunt ipso uenientes ore patente
Nec requies era ulla mali: defessa jacebant
corpora.

It's useless, you can cover them with neither feathers nor paper, but the weight of the wind, of the cold, should always be enough to clothe them. And when some extinguished their burning metal in the frozen rivers, throwing their body in the water, completely naked; others, falling into huge and deep wells, saw their mouths, opened, aghast, converge.
No interval in this painting: all the bodies were immobile, broken.

Figure: The Mazzocchio

At this point we have to read the function of mastery and distancing in respect to two disjointed moments of writing, of the *mazzocchio* conjoining two facets, in its cutting impact, and in its encirclement the two points of an arc of color; an equipollent blazon of a single color on its two limits, on the two terms that it can express, hanging by the neck of a man and set on the head of a woman / the black and white, as a value of green, Leonardo would say, remain the utter extreme of all the perspectival effects of all colors / ; in their infinite, circular permutation, the black and the white repeat, on the dispersive facets (the optics) of the mazzocchio, of chromatic visibility. A buoy of color hanging on the neck, on the body whose difference it affects. A body affected or tainted by a chromatic difference. And, brandishing its club, the body is set in this ocular ellipse thrown out of orbit: a kind of body conceived as an etymon. Here the mazzocchio is returned (by way of synecdoche) to the figure that carries it. Affected differentially, it is the body of an extended metonymy, the etymology (the distended articulation) of the encircling ring: *mazza,* the bludgeon, the club, the painter's maulstick; *occhio,* the eye of the painting, the gaze of this spinning object. All the bodies are set in this arc, carried off like a seed into the black, charcoal-like gum, as if toward the ultimate point of visibility of one and the same quality of white.

The Mazzocchio, The Referent

Here detail is not the removal of one element, but a transformation of the overall economy of the design. As a suppression of the depth of perspective, it is an operation on the topical referent-signifier-denoted. This topic (*according* to Leonardo's theory) is marked by the fact of its unsettling effect in the flattening of perspective (in the attention placed on *this* detail: the zoom-effect). This zoom that constitutes a background of the painting in every figure is, paradoxically (and consequently, in a direction *contrary* to Leonardo's theory of perspective), what casts the referent aside so as to appear to be furnishing denoted material.

Traditionally accepted as what is kept at a distance by the sign in a denial of its slight difference (the basis on which it casts its

resemblance being exempted), and kept at a distance as an origin, the referent might be defined as what does not keep a distance; what the shattering of the sign (in *The Deluge*) or the fable of semioclasm (*The Profanation*) casts aside as an element holding to the very exemption of the sign, since these two operations are only making manifest a signifier in excess (they are effectuated on a space of abolition, of the consummation of the sign in the "realistic effect"). But the same thing is written, produced in painting, of two bodies situated at the juncture of vanishing points, of the white body fleeing its identical other of soot, placed in the background of the fresco in a literal paradigm whose bar is painted in the tree blown over by the wind and reinscribed in a crack that is fissuring the fresco along this line.

The Mazzocchio, A Figure

In Uccello there are shards of plastic anatomy. Shards, because objects are at stake, figures whose perspectival, symbolic function transforms the general economy of the design. They are inscribed in terms of a repetition or a denial of a bearing (in the ballistic sense) of the apparent signifieds. These figures are defined in a kind of condensation of symbolic effects (the mazzocchio: the buoy, the headpiece, the boa, the facets that disperse meaning), are always playing on a striking incongruity that, by means the referent displaced from its calling, represents the coming of a pure signifier of the / system, / that is, of a term that constricts the system by means of an ironic effect of distancing. It is thus subtracted from what would seem to be the bearing (made to look natural in the *narratively convertible* system of the figure) of the signified. There are—and this always inaugurates unregulated symbolic functions (outside of foreseeable perspective) that are emblematic of the obvious structure of the system—an apparition of floating objects. Floating in the text, these objects reveal a saturation of the text's power of symbolic absorption: what they are twice stating is the text itself, and that the text is written from its specific other (nonlinguistic) side, which is the procedure (manifestly perspectival, stereographic) in which this painting is written. *What the referent's quasi-eruption brings into view is not a stubborn persistence of the real but the debarment of every new sig-*

nified with the system in which it is exhibited. Because of this pure signifier the invaded signified becomes the irony the system upholds. "*That's it*," that's what (this signifier) means: this signifier (this mazzocchio) is a perfect deictic agent of the system (but who here is uttering, "that's it"—if not the very subject of the painting in that it would be the subject of its own science?).

(on the left the Deluge, on the right the ebbing of the waters: the terms of the last judgment)

The receding waters carry the system's signified: "the painting leaves behind it, and the color by carrying its symbolic indexicality off in the other direction, of pallid, dumped, discarded bodies, flowing over the lateral brown background." To what are they affixed? To what and by what are they holding?

NOAH'S BODY

A frail statue of the commander assigned to his return (*Noé gradivus*) scenically upheld by every mechanism that is running through the depth of the painting. And, first of all, with this bad precept according to Leonardo: that the folds are propping up the body ("in painting the body is only an additional fold"—that is a signified of the system). And a pair of hands punctures the surface, holds onto the body of the painting by its feet. The body, in the instance of white, in the folds, losing—paradoxically—all sign of volume: a flattened body, seized in its death-like effect, in what it repeats, peeling off the law of the painting. But this body in its flat statuary, its feet posed as if in Egyptian statuary, yet pegged, set by the hands of the painting, teetering, a statue of fresh plaster, led onto the proscenium like an immense, fragile marionette, whose plaster has turned green in the folds, on the face, a sign—before it shatters and crumbles into dust—of slenderness. Between the two movements of the ebb and flow of the fiction, just short of this side of the line of the painting's ebb tide, Noah travels on the foreground of the scene; he is buoyed up there, before the wings of the stage, on the last tug of the hands, the fists, the head of the puppeteer emerging from the painting. The body passes, a block of sculpted, chalky stone, Uccello's portrait gazed at and stupefied by the body behind him on the dividing line, rising out of the barrel (a body emerging from the vol-

ume and that sees the sunken back of the statue). Like the wa-ki on the platform of No theater, a stagehand, he rises up hoisted, without ever "touching" the space, the ground (or without raising his feet). Here, as elsewhere, there are no subjects, but types, species, and statues, as if painting, between the wooden funnel, had become incarnate. Against the jaws of the navigation. In his figure of chalk Uccello passes through his fiction, his biography ("[il vostre abate] fra torte e minestre fatte sempre con cacio mi ha messo in corpo tanto formaggio, che io ho paura, essendo già tutto cacio, di non esser in opera per mastrice; e si più oltre continuassi, non sarei più forse Paolo, ma cacio"—Vasari—and, replies Uccello to the monks who wanted to retain him, with all the cheese you feed me I'll no longer be called Uccello, but Paolo the Plaster, *The Life of Uccello*).

> *plaster:* calcium sulfate (hence: cheese), a white cosmetic, "too much" cosmetic. Plaster used by casters requires special characteristics: it is obtained by calcifying granular and tender tablets in bakers' ovens, whose temperature hardly exceeds a reddish-brown tint. After it is cooked, the plaster is immersed in a thick wooden basin containing an aqueous solution. (This plaster is also the extracted condition of the workings of color. Flowed, molded in the water of fiction.)
>
> *cheese:* on occasion, casein is used in place of albumin in various photographic processes (for its capacity of phototropic absorption). Animal casein is digested by peptic acid only with difficulty. It is first taken in gelatin, then is liquified. . . . Milk casein now plays an important role in industry when used for the manufacture of diverse plastic materials under the name of "Galalithes." Galathea, a milkstone. Furthermore, in this field of knowledge (that of the dictionary), by way of detour, in Uccello's biographical substance, his cry of protest.

Uccello, a chalky prophet, put on parade, fords the width of the painting. He moves on this plane, carried, hoisted, slipping through his personages, toward the stage exit, the black rag.

≋

The black rag: on the right, Vasari tells us, a cadaver in perspective (what a pretty thing this death in perspective would be if it were

no longer a body floating *sideways* across the space) whose eyes a crow pecks out. A crow in what is nothing more than this fold of a black rag, a piece of dirty laundry that seems to have been left on the ground in the fresco, but outside of the field of view (and the focal/fecal point) by both the painter and ourselves, just after the moist surface has been wiped off. A crow in this black rag whose inverted folds state that it still moves and that it is cutting. Thus being deposited on all the blacks of the screen, on all of its stains.

THE PLAGUE OF ATHENS: 2

Item ad supremum denique tempus
compressæ nares, nasi primoris acumen
tenue, cauati oculi, caua tempora, frigida pellis
duraque in ore, iacens rictum, frons tenta manebat
Nec nimio rigida post artus morte iacebant.

The Statue

in its hands the nerves are contracting, its members tremble
but first of all the feet that the cold is gripping. At the last
 moment,
its nostrils compressed, the point of its nose tapered, the hole of
 the eyes,
the hollow temples, the skin of the face cold and hard,
its lips puckered like an anus around fallen teeth, the leathery
 forehead;
with a jolt, the statue begins to walk.

> *Multaque humi cum inhumata iacerent corpora supra*
> *corporibus, tamen alituum genus atque ferarum*
> *aut procul absiliebat, ut acrem exiret odorem*
> *aut, ubi gustarat, languegat morte propinqua.*

The Towel

and piled on the ground, bodies one upon the other;
but the birds and vultures were trying, from afar, to separate their
 odors
and if they happen to eat them, upon the stage they are
 immediately taken

in the folds of the corpses,
collapsed.

And hands pegging the feet to the point of breaking them, a paradoxical body of painting, a chalk porcelain with the imminence of powder (it's going to crumble to bits). A body of cheese. Here a great figure crosses through the history of the painting. And what can be kept of the whole painting, if not this passage? Uccello's life moves across the painting on this plane: the theorist of perspective; a blind body, a witness-machine of a derision. Held by its instant law, the negative, the minus sign *insists,* like its folds.

The recession of the waters, act 2 of the drama, is the apparition of folds and of cadavers: the two bodily movements of swelling and bloating; the second act (the other remains) of the painting that is speaking here, since the instance of a negation of the real, its system provisionally suspended for a moment in this fresco.

In the coming and going, from the deluge to the ebbing of the waters, the system of the painting in the movement of bobbing bodies (but these bodies once again are the "figures" of painting: and, if this literality were hanging onto nothing, then what— unless it were the concomitant defection of whatever is staging it—would its figurability be holding up?). To speak, to write, to follow the fiction and to see it *crosswise,* when, at every moment, it is being saturated, the painting returns in order to incline its stubborn transitivity of a narration that is always ready to depart but also, specifically, to pursue colors outside of this disproportionate levy of bodies, upon the insistence of a negation of the real that, like its text, affects this painting.

OF BOILED FISH

"The natives of the waters will die in the boiling flood" (Leonardo da Vinci, *Prophecies,* in *Notebooks,* vol. 2, 358).
Of Water, which flows turbid and mixed with Soil and Dust; and of Mist, which is mixed with the Air; and of Fire, which is mixed with its own, and each with each.

All the elements will be seen mixed together in a great whirling mass, now borne towards the center of the world, now towards

the sky; and now furiously rushing from the South to the frozen North, and sometimes from the East towards the West, and then again from this hemisphere to the other (*ibid.,* 361).

And fish that fly out of the water. Can we not, as Ferenczi says, also say of these poor, exhausted animals that are unable to float on the earth? In its title, "the boiled fish," the fable in which, in its very first indexical sign, its initial scene, a tale is told of the inexistent indexicality of the painting.

The painting's stereography in these bodies as a product of its color: in order to see illusions of truth we would have to note what remains in the black-and-white reproductions.

(What is also required in our reading of the dossier concerning the *Deluge*) is the character of Noah, in respect to perspective, in correct proportion to the arc, to the totality of the figures. But what is stated in this instantly upheld casting (and never has this adverb been so correctly upheld), is that this body erected by the figures does not stand up; beyond their measure it traverses them; passes immobile through the space, caught in a diaphanous prism: the whole painting and the depths of its fiction are clearly the canvas, the background, the wall on which it passes but which to which it is pegged, attached as if to its shadow, by the puppeteer. The shadow starts at the feet and flees the head. A body without a shadow. Its law traversed: "fiction is the depth that is produced on the plane surface." "Painting is inaugurated scenically, is designated by the indefectibility of a negation of the real." "In painting the body is merely an additional fold."

In representing wind, besides the bending of the boughs and the reversing of their leaves towards the quarter whence the wind comes, you should also represent them amid clouds of fine dust mingled with the troubled air.

Painting is inaugurated nonchronologically, semically (?), from the indefectibility of a negation of the real. "How to paint wind": how to represent in painting? the wind.

The wind of the painting literally sows the seeds of nothing.

Space, upon its deepening, trampled by figures set out of line, shoved (by the volumes, colors, twisted proportions) as if, all of a sudden, after a timeless suspense, the whole painting (held up in its movement by these two wooden stage wings) were *pouring*

upon us, like a speeding car, like a tidal wave. Like color returned to its liquidity. But here there is no water, the land is dried by effects of wind. Inasmuch as it directly affects painting, water is nothing more than the color of the bodies (set in an arc, of the body arched out into the color, of the body set onstage in the arc of the color). Once again a woman is spitting (is not rejecting)—she is the spurt-woman, the amniotic body—the water of painting.

THE BEATER

In the violence that encircles his drift away from his pedestal, the very movement of this baseball player, a batter, or rather a beater, brings forth a masked face. Isn't the (jagged) relief of expression in the facial traits the very pressure of the body that crushes it down, the sunken, blackened eyes and cheekbones emitting shadows? A mask, here a crack of the painting, blinds one of its figures. A black square in this text: "the subject of painting is blind" (it's a signified of the system). From its undrawn, not unbound, massive feet. Its hair is curled, like a turban, against the wind, twirled in the back by the wind of the painting (these tresses in broken lines, like the sign of water in all Scripture, crenelations in greenish color over the mix of white-green-black, punctuations of the bellowed wind).

What makes up some of the painting, like the other text (of literature, that is always "in the process of being written"), is perhaps first of all the fact that only its complexity can be understood (and not its meaning; to the contrary of the idea that should like to put meaning before this labor of articulation that constitutes the mechanism of meaning, or signification: manufacture of the signifier; for it is not because it is manufacturing ready-made signifieds that it *drifts* according to standard operating procedure), without our ever being able to say when it stops, or that nothing is concealed beneath, but that it "navigates" over history. For this capacity-to-mean belongs only to the painting, not to the battery that grasps hold of it, and it's a power of *hapax*: of a text without redundancy that is pluralized upon single instances. And while the topology of figures owes paradoxically (in the working of "their" negative) to the meaning, they are proscribing only imperfectly (they are not the countermarks of their signifieds, as

iconology would have wished), they are exactly prescribed in the very movement that exceeds them: such is this unforeseen, comminatory economy of all the scenic explosions that earmarks the figures. Such that the figures are neither drifting away from linkages, ordering principles, nor from a wild grammar that language, that discourse, would happen to fill, solidify, and embed. Like the contract of representation.

Discourse, language (with whose loss this drama is playing), are not the complement of representation; the fringe, the grid that would be sustained, in contradictory fashion, by their permeability (by letting meaning "slip through") the faltering space. The great sweep of an order of words. Language is taken here not from its complement, from its program already traced in a void, in white ("the drive to represent," that Vasari almost writes, would be the refusal, the emphatic deviation from the bodies of grammar; and from this sententiousness, like unmoving statues, the signs of a denial of language). What plays on and in the representation, nonscenically but ideologically, is not just an instant summation of the discourse *behind* the figures, but a summoning of language placed in a scene of impossibly specific writing.

. . . a walk along the obscaenia of the fresco of this great solidified, caseous concretion that is Uccello's name. And who does not say that "the subject is an effect of the signifier"; more mutely, moving across, slipping by, shared here and there in this other oblique travel, the proper name is upheld by its derision, definitely this other, ruseful, vacillating law—that returns to the provisional background whence it was torn—of the painting.

But why don't we leave a blank space (of distance) in this judgment, in this pronouncement, at the very moment of its utterance?

> "On the basis of this theoretical precondition a case can be made . . ."—but a precondition in what time, if that is what is producing it, a precondition (it has to be respected) entirely held by its aftereffect—and notably, of this law:

(endless passage on the other side of the figures of this statue of solidified casein, thinned, a bobbing figure that is stuck to its brown-colored pedestal—"set" on the ground with its two right feet on the same line, and in its hands that hang onto it in order to

55

be hoisted up to the level from which the painting can be seen [this figure that emerges out of the ground, a prompter beneath the stage, flattened, laminated, sent back into the fresco], the hands, the calm look, surging out of the color, directly make Uccello's signature "convincing.")

> "but the law—the uncertain law—that must be attached to this unique passage: of the staged derision, by way of detour, of the subject: *that the construction of the signifier is denoted here by the loss of the topical subject being inferred.* And for the topical subject that here is the bottom side attached to it, the pegged, bilateral, sidelong subject of writing. And of its converse: that the loss of the topical subject (exactly what we are studying) is denoted in what is inferred from a structuring process of the signifier."

THE SHADOW

Here the shadow, like a rubbing of the body, this kind of positivity of the signifier, is what is constantly moving here. It is seized not by a site of the topical body but, we might say, by a positive stake; its stake is not that of application, pieces plastered-on or flaked-off, or the simple out-of-bounds of the body. Its stake is this "taxonomic setting." Not a complement but a varied body (just as the mazzocchio is a body of hardened, solid painting and set in the spinning orbit of a pulverizing or comminutive power: its dispersion—what it rules and what belongs to it—is the gain, a gain of pleasure, of a new, unheard-of order). The shadow, an understudy undone, a bodiless blurr, is set in the profile in a paradigmatic perspective.

> "Many a time will one man be seen as three and all three move together, and often the most real one quits him (of our shadow cast by the Sun, and our Reflection in the Water at one and the same time)." (Leonardo, *Prophecies,* in *Notebooks,* vol. 2, 362)

The role that the shadow plays so economically is related to a calculated effect from which the signifier is renewed. Metonymically, the painting presents on its surface the elements of a topic: the same elements at once serve as the painting's substructure, devices that animate the fiction as an autonomous text in the painting, as as an autonymic text about the painting. Thus, we

can say that every figure here is a working figure, but in a contradictory way: if each works as far as the structural readers (*lexia*) on the appeal of texts whose staging the painting allows (but the painting is the beneficiary of this staging) in an instantaneous, contradictory fashion. The painting, however, does not *hold* (structurally) *to* the figurability of the text in which it is quoted. Its topical anxiety turns it into the fantasied site (but not the phantasmic object) of several writings. It is the intersectional object—more than a differential object—that, for centuries, literature has been unable to rejoin: a text whose topic or theme is destroyed and reallocated to "foreign" bodies through its own labor (signification). The play of the painting (what would turn it into a representation) is not an additional phantasm (of literality) whose idiom, whose discourse, only utters a minimum; it is because, justly, moving from one economy to another (from literature to painting) the phantasm disappears. The referent is no longer the phantom of the signifier: because painting is working *on* the referent's slightest indexicality and *from* negatively resolving the signifying conversion of the referent. The signifying topic is dispersed over the active loss (in a working) of the referent as signifier. What is displaced (and this displacement is an intersection of writings) is an indexical function: there remains nothing of the minimal pertinence of the referent because the referent has no color (no system).

To move from the text to the painting (e.g., from the writing of the Marquis de Sade to its tableau vivant—the phantasm that "upholds" and unwrites it—in the painting) specifically means that the phantasm is not a translative agent that converts one text into another, but that it disappears.

THE PLAGUE OF ATHENS: 3

The Disposition

the one who escaped from this loss of a black blood
watched the painting descend into his joints and especially into
 his testicles.
Terrified about looking out on this perspective, they tried to live
 by cutting up their members.

Others stayed alive with their feet and hands hacked away, and
 still others enucleated: to that degree the fear of dying had
 sunken its blade.
And there even existed what the oblivion of all things seizes to
 the degree that they could no longer be recognized.
Stretched out, immobile, already beholding his burial, that
 person cut himself in two.

THE FOLDS

The back of the woman with the mazzocchio. The Florentine fold
is emphasized with touches of white: here this figure of painting
offers, according to a stated necessity, what keeps its stakes in the
figuration; it is an apodictic statement that upholds the system
(such an a fingernail "made flesh"): like another figure of blind-
ness, on its obverse it supports "whatever does not see in the
painting." The space of the fiction is a tragic fold in its tiniest
detail (—since the Deluge of the painting is heightened by a
disproportion of effects: its objects, its bodies, their syntactic
placement are thrown back to a kind of immensity of the empti-
ness of the painting's labor—here there exists no dramatic veil-
ing, because of a prescribed theatricality in its rhetoric, that
would take up a drama of the painting). What is grazed on the
woman's back and in the two rumps that set her in her place (the
woman's rump, the rump of the steer that she straddles) is the
domestic blinding of a body of painting (its dramatic incongru-
ity) that moves sidelong toward the center of the fresco. Here, as
in a bazaar, the end of the world is merely the precariousness of
all the piles of merchandise: they are sighted only in a taxonomic
defeat; helter-skelter, but provided with transitory places, in its
place every floating object is transhistorical; it at once crosses
through an entire body of fiction and the law of figuration: cross-
ing through, in the same movement, the forever presupposed or-
der of a signifying topic, but taking sidelong, like a body without
repetition, the history of painting. Its tiny place is symptomatic,
akin to a vital part and an instable categorical unit of a fiction (the
figuration of the Deluge) of a great derangement of the cosmic
order. By way of this laborious signified all the signifieds of the
system are in contact with one another; from that point, too, the
meaning "manufactures" signifying bits. Every figure signals the ap-

parition of meaning in this taxemic instability. The latter is not its restriction but, more exactly, its economy.

THE ARCH, THE ORGAN, THE DECOR

Here the arcs constitute two tipping panels, whose literally capsizing movement conveys a sinking effect. The splayed opening hinges on an axis, one of its vanishing points, on which the general figure of the dehiscence turns and develops. This figure organizes the scenic aspect of the fresco; the historical, immobile "fresco," set and cast in a myth that could begin nowhere other than in the simultaneous upheavals of time, and chronias—that exhibit it and retain its power—by condensing all the effects on a scene that is connected, linked, and polished only in the recurrence of its tearings, divisions, ruptures, that run through it as a unique scene, an unheard-of power, in a theater in which Uccello was never set in place, constantly to be "subtracted" from a story. What organizes this space is not (according to the "teachings" of perspective) a metaphysical theater or an economy of meaning guaranteeing an annulation of signifying labor: it is a violent figure outside of discourse, but not without language, that mobilizes only one, nonmimetic, actor: a violent mistake in respect to the species (and the space itself) of the signifier; that, while attesting to its clear division, does not let itself go unaccounted for.

Between the two fabulous times (here referring to the labor of an empty chronology of the workings of the signifier), between the two arcs—what they "contain" are also, outside of the theater of the painting, two voids of time, an "improbable" before and after of painting: their split brings forth an inside of the painting akin to the outside of what they enclose: a swinging design that crushes the immersed, floating bodies, the space of the triangulated fresco, somewhat like a slice of cake, that is a spliced time of fiction, of a narrative: its total slow motion, the reduction that allows its figures to be exhibited as figures of painting that do not return to the story from which they have been ripped away (and is this drowning effect in the painting something other than a very slow tearing—that moves all the taxemic units of the painting—away from the fabulous, mimetic reason of the bodies of images?).

59

As a piece of time spliced into the fiction (no prescriptive discourse, no testamentary knowledge, no dead prerequisite of biblical wisdom can sum up the text of this painting), space is, exactly, the declension of two moments of biblical history: in the detour that puts together, in place of a figuration, all the personifications of painting, can the third dimension not be death played to the deepest, ultimate point, where figures are crushed and colors are divided? The murder, the refusal, at the fingertips, of the comminatory Testament of representation?

In a play of figurability the third dimension is not an additional depth, a grafted code of knowledge. It is a rewriting, spliced, out of synch, of what this code *does not cause to write:* the painting.

THE RECEDING WATERS

on the left the Deluge; on the right the ebbing of the waters: the terms of the last judgment (classification, in the prescription of the denominatives, brings forth an eschatological power. It is the entire force—playing on a stage that tends to "confuse" them—of acts, moments of taxonomy). What is borne in the classification, in that it supposes the fresco to be already painted, or takes from its program, is the emplacement of a signified for the system: "Painting leaves behind, while color takes away, from the other side—on the denotation of a first act—its symbolic indexical power, from pallid, trashed, rejected bodies, washing up over the brown lateral base." At the same time the background, the last wall from which acts of representation peel away in the figures, is the invested depth (on its differential scale): the chestnut-brown, evidence of a more-color irreducible to figures, that in the fresco presents the wooden panel (the tavola) of the (ancient) painting. And the basic, *untranslated* drive of the painting: in the anal drive, a "mouth" of the painting. The swinging plan of an overflow and dejection of all the bodies washed up from this side (and that literally can no longer hold up): "Dead, men will pass through their bowels" (Leonardo, *Prophecies*). (In each point, like "a prism of turning obscurity," the painting touches the text whence it is written.)

As if through one of Uccello's own decisions, the shadows are carried to the left, out of the spot where, before the ebbing of the

waters, he is shown in scenic view. But a retrospective view is obtained on the righthand area, the shadowless bodies being swollen up again, denoted, we might be tempted to say, by the end of a scene that illuminates the left side (the swimming, the drowning, the immersion, the battle, as if a precipitated, jerky, slow motion of each figure in a same, concatenated movement, "how to swim on the surface in the painting") and illuminates it in the exact proportion so that it is being endlessly darkened, dividing it, and blackening its moments.

A labor of painting: the second body in profile on the arc in the paradigm of detachment ("this figure of painting is a blind subject"). Nude, an anatomical study whose head covered with foliage is agitated by a gust of wind (seen in the streaked hair, broken lines of water painted over the mass, the helmet of hair), unburdened by its shadow and, in the perspective, brandishing the club that a first character (the one with the turning yoke of the mazzocchio: a figure of colors / an unstable module of perspective) rides forward into the field of view and toward the knight, who enters into the scene (the tavola), brandishing his sword, producing this blade that theatrically cuts all the figures—and cuts them like the signified of the system—from their themes: that is, the univocity of a semic power that makes all the equivalent objects converge upon a single body: what the perspective disperses is that multiple, pansemic function of a prismatic force of the body (but here only one body—the mazzocchio—classifies by turning the crests, the simultaneous facets of meaning).

/And this seed thrown into the wind of the painting is old Noah (the aging Uccello in this self-portrait), his torso emerging through a window in the painting's lateral background, who, with the skin on his hand like parchment, gathers the dove's olive branch. He also blesses his double, who is made of cheese, and he gazes at the man in the barrel (Hieronymus Bosch), who is staring at the backside of the enturbaned subject, draped in a Florentine tunic, who passes by/

It is astonishing, in passing, that this painting is set indefinitely in a procession of the painting and that it produces, even by counting the masks that the leprous fresco sticks to its wall, an

entire history of painting: Masaccio, in the background of the fresco, and Poussin too; in the body swinging the club, a sketch with Michelangelo's three pencils (the Battle of Cascina, the Fire); in the man climbing out of the hole/barrel: Hieronymous Bosch and one of Signorelli's figures from the Last Judgment; the foreshortened body on the right is a Mantegna (Vasari notes). Then where is Uccello in all this? He is what paints, in advance and from every point of view, the delay of the painting. And is he not also painting, in a great movement, in advance— in this fresco—the asymbolism of painting in general?

Set in a double metonymy, the body, in two paradigmatic series, with a broad stroke of the club, fells, or finally liberates anatomy, a problem of painting. The same body, a white intersection of series (the three bodies, the three shadows / extended metonymy of this slow battle of clubs), made blind by a leprous paint, from a chemistry of water, and from the coloring agents on the Florentine fresco, buttressed, erected, caressed-with-light. It savagely holds the secret of afterlife (and what is this club, a metonym of the body, of the forest?), of bliss: that drifts toward the background in great tremors, in the opposite direction, upon its islet. A body, another body, a stereography of painting: great bangs of the gong on the arc: the organ, the pianist (all the bodies rise and descend: tossed about like corks), the rhapsodic bellowing of air. When it is being written, the painting is affected with a declivity that redresses it.

SHELLS, CRACKS, SCALES FLAKED OFF

multaque per populi passim loca prompta uiasque
languida semianimo cum corpore membra uideres
horrida paedore et pannis cooperta perire
corporis inluuie: pellis super ossibus una,
ulceribus taetris prope iam sordeque sepulta.

on the body glued against the arc, breaking off, a scale of painting has ripped its face away. A vertigo of these scales flaked off as if a fingernail were scratching the surface and making another depth of the text appear under the coating. In truth it is only inferred since the upper window by which it is enframed only allows one color to be glimpsed. But this color also brings into view the

labors of the the initial text. And this "demonstrative" in the broken fragment (quite unlike another system of textual scratchings, mildewed surfaces, claw marks) might only be designating the painting's *defectibility*. The palest reproductions (copies taken from black-and-white photographs) are no less indicative: it appears that these disruptions succeed one another as might so many prescriptions of the text of the painting. The mildewed spots are set on the pictural plane, on the lefthand side, like an effect left by water. On the righthand side, the claw marks, the negative flakings, or scalings, are caused by wind and rain. The points broken off by the bending of wood or the Gothic buttressing of the bodies. A great fissure coming out of the sky cuts the tree diagonally, between the two bodies that are separating. As soon as we watch out for it, this space appears striped, stained, raised by a slight gust of air under the color. There are thus various degrees of wear as in a code (of wear-and-tear, of courtesy), a protocol of the painting (and some of the first applied leaves, spots of glue that stick like an opaque varnish): don't let all the texts be eaten away at once; the classical writings that show through (such are their surprise effects) are the oblivion upon which the painting "appears"; as if there existed behind the painting a space whose entire power entailed "cracking" the first layer in order to become visible.

UCCELLO'S LIFE

Uccello is an obsessive system. Vasari noted his maniacal bent to fetishize: perspective, colors, fascination for detail, constructions, obsessions with animals. Uccello is afraid of cheese (out of an ontological fear). By contrast, every day Pontormo eats a fabulous quantity of eggs (day after day his journal chronicles this monstrous ingestion: Pontormo is an egg counter). Before his cleaving, or becoming a subject, Uccello is the intersection of several contradictory texts. His symbolization (his work) is his escape out of these texts. The subject is the blind knot, crossed through by what he can read in only one mode of time. A hiatus in the time of the labors of the signifier.

THE PLAGUE OF ATHENS: 4

end: the debut, the debate. Who thus in the depths, in the background, in the mannequin, is inhumed? A purloined body, an ungodly sepulcher.

Namque suos consanguineos aliena rogorum
insuper extructa ingenti clamore locabant (the square, black
 mouth)
subdebantque faces, multo cum sanguine saepe
rixantes potius quam corpora desererentur.

at the beginning, in a position of what is inhumed in the other place, the debate, rather the tussle, in sum, over deserting the corpses.

In the Athenian painting there is only one form, states Lucretius, the allocuted: "You will see their bodies sullied, but you will be unable to clothe them," only one person: the allocuted.

sed a quo verba proferentur? The allocuted. *Uideres membra.*

The entire symbolic process (and thus the entire system of the painting) is based on this active lack. No one says "I": how the allocutor is an *address,* the mythic subject whose proliferation works through the bodies of the painting.

THE PLAGUE

THE GUTTER

we have to speak of the *poverty* of Uccello's painting
painting of a great pallor (an arch erected between Dante and
 Vico)

the painting appears to be fastened to an enormous gutter

We are dealing with a relatively *obscene* painting simply because it does not take part in a figurative theater. The body within is obscene because it is (with all that is believed or that must be implied in respect to the history of painting) pretheatrical or, put more simply, nontheatrical. I am thinking again about the passage of Saint Augustine that Artaud quotes in which Scipio Nasica declares quite oddly that in the time of plague all theaters have to be destroyed. It is as if the body were seized by another *urgency,* literally, of an entirely different kind of burning that was keeping it from *being staged:* no scenic unity, no scenographic organization, in these nagging doubts weighing on the body. Here, quite uncannily, it *becomes massive.* This is evidently linked to a kind of quality pertaining to what might be called the mythological signifier. It is a state of body: a papillary, emulsified body, completely indistinguishable from its shield, that does not yet take up figures unless they are profoundly anonymous (there is at this level the workings of an evidence that brings the painting forth while it ploys its fiction, while breaking it in two: the body of mythology is arched under the tempest, the first storm—here Vico's recurring storm—by which the opera of history begins with a clash of cymbals). A homology or a sort of porous passage between the labor of fiction, figures, and colors. It is even the symptom of a kind of dramatic quality, of stupor that is so strong. It is Vico's thunder.

≋

A Universal Deluge? Because that awakens something that remains mute within me. Or rather because that awakens me next to a grown-up astonishment: to see drowned, enmeshed, and tossed topsy-turvy some kind of enormous bric-a-brac of memory. A rain of bodies. A catafalque of whitened fleshes. May the beginning of history return in this swimming, urethral memory. The tangling, the plugging of drowned bodies, corked up like massive horses crudely shaken. May the painting begin here, in the fable of the second humanity, the ground touched through water of the fresco. Don't capsize, drift, and drown right off. Where the painting begins (monstrous opera of the *anatomy*). The first that could care less about the morality of painting. It is painted in masses, detached in an earthy depth, miring the drowning of fabled bodies.

Uccello doesn't care, but he lets himself be tricked by a monk with fat jowls, defecates on his dirty face, swallows, and succumbs to violence again.

Here then is a unique figure (a painting, next to his contemporaries, that is neither pretty, nor affected, done with loose, broad strokes). In desperation there is Ulysses' force: all at once, and appearing in a cooked space, in the baker's oven.

A haughty painting that sends streams of shit in our face, a slobbering space (delay of all the Botticellis). The bodies of painting *fall into* the shell.

Without affectation. The first theater of the painting, the subject of its delay, sets forth onstage, that the separation of the body shows rowing in its muddy areas. A body of another time beginning with its gills, turned on its point, a vibrating finger, a tremulating body stretched under its space. Today painting its waste.

We ought to speak of the impoverishment of Uccello's painting. This impoverishment is what makes us shiver because he is correct, his eyes in the water, his head listing, because he makes the other painting useless; immoral, because he makes any richer meaning immoral, or exuberant.

The feeling that on several occasions (Deluge, Profanation, Battles) Uccello wants *to be done with painting* in order only to retain its shock, its collision, its affront of meaning in its deferred brutality: it's up to us to nail ourselves to his arched body of memory. The subject here? Uccello's memory.

Piss, corpse, sponge, specks of milk, a stem of the head touching eyes closed upon the night. A memory riddled with fabulous bodies.

In broad strokes, a classical theater, a Christian theater.

It is through his hands, with his arms gripping, taut, his torso that pagan memory crosses through the body of Christendom and, in the opposite direction, a hate of his own body.

The inside of the boat is the hoop net: a mass of the body swimming, veering, stroking, splattered with white on its fringe.

Paestum? A city destroyed at the time of the plague? A city of God decayed, crumbled to bits. An anonymous mythological body and, in a mass, a body of fine powder.

Scipio

Scipio Nasica. Black nose, *paper* nose:

"the gods had ordered skits to be performed for them, in order to pacify the plague of your bodies."

Dii propter sedandam corporem pestilentiam ludos sibi—*so that the pestilence might be calmed but by sitting in it*—scaenicos exiberi iubebant—, *the gods had ordered skits to be performed for them, exposed, tossed right up to their fingertips from these burning floors.*

Pontifex autem (*but the one who was bridging toward them*) propter animorum cauendam pestilentiam *in order to protect the souls from the plague* ipsam scaenam constitui prohibebat *forbade the erection of this very stage.*

and thus, above all, so that this image be divided,

and that the bodies inhabited by this burning theater would not erect the stage where the soul would take the gods, the plague,

and that the stage in this theater would not be seized by the division of body it inhabits.

≋

Fists at the ears, mouths in coal: may the body leaving the scene be deafened, on the soul that represents it,

if, in a flash of lightning, (si aliqua luce mentis animum corporis praeponitis) you place the soul in front of the body; if, be-

fore the body, it is this movement that you are placing, then may the body spurt its ink!

This plague has blackened the spirit of these sad souls with pitch. It has painted them with so much horror (but no one would ever wish to hear it) that after the sack of Rome the plague overtook them, and those who could take refuge in Carthage went wild every day, at the theater, in front of the stooges; burned by their coal, in front of those bodies, exactly: losing their heads; spinning tops.

≋

And this sickness, this plague that *leads to the theater* (a refined madness insania delicata ludorum scaenorum, of a people that until then, at the chariot races, swords' edges, sacks of sound, the arena pummeled, bloodied bottom, crushed clogs, torn hips, battered backs: brutes!).

≋

Why look at the painting here? At what in the painting? What theater? Already on the corpse, the recumbent body's desire, the dormancy of the signifier.

Defoe, *The Journal of the Plague Year* (a procession worthy of Bataille, of this way of positing the "I" that, through its awakening of writing, first of all makes little of the one, no matter who, inhumed in this desire, trembled)

. . . In the night I wanted to go and see the bodies thrown into heaps.

To prevent further infection strict orders kept the people from getting too close to these pits filled with bodies, and these orders soon became mandatory, since the infected, approaching their deaths in a state of delirium, ran about enveloped in covers,

(the desire to see the spectator of the charnel house pass by like the phantom of death; in sum, whatever is there pushing up, running around, already draped in a shroud: the statue *walking like a cadaver.* What does it all amount to? grotesque, the cover, tangled up in a bag race!)

in order to bury

themselves, as they used to say (stop on this kind of breach: the redoutable time of this fiction, the draped bodies that are tossed into the pit, *were saying,* "they were saying. . . .")

MEDEA

Plague, theater. It's even the occasion in this decomposition of the body, in its terrible erosion, to display, writes Saint Augustine, the execrated body, the body that, like a swollen bruise, exudes a kind of mental pus: those who were escaping, having taken refuge in Carthage (pressed like crazed sardines on this broken bridge of Roman memory), were piled onto one another like maddened buzzards, pro histrionibus insanirent, lost their head in seeing the stooges, in other words, the delegated body on these theaters of their execration.

What is this imminence of the body on its painting, and of the *pendant* body?

Something that *stumbles* so frontally—here and there we see the same angular opening, on the witness or on the *dislocated* body, but that comes like a hand, in the slippage of the panels of the scene, to take up once again this abruptly suspended spectacle; it is arrested by the monologue of Medea, anchored in the foreground on her sword, and by the cube (the one on which Mileseva's angel is seated) upon which two children are perched like chickens on the stone. This Medea "meditating (or 'already facing': turning her back to the painting, she sees, with a hollow gaze, this infamy 'passing' before her eyes) the murder of her children." What is happening in this barnyard drama stripped of all solemnity? Are the children playing at their dismemberment when they are rolling dice on the sacrificial altar? It is an image that I can imagine upsetting me so strongly (a biased, frontal image, pale ochre, a more washed surface of the wall, like Medea's mauve dress buckled with yellow, a frame opening onto white: the stupid image of Egea, the door to Hera's temple). The signifier: is only what leads far beyond itself. There there is a referred

signifier (that is what gazes so violently: there exists no *correct* reversion on the meaning, but a *blade,* something that modesty impedes). A rare feeling of the *jelled* brutality of this place, with this Latin word, to which the body suddenly is addressed, *palpantibus:* to other bodies that grope about; as for myself, all at once the fright of meaning, its inverse, and its invented memory: paganism (Medea in the Museum of Naples).

(Medea? one of the most "unstable" of all mythological bodies, here with Euripides' dagger, like a menhir of Filitosa)

——the text happens to disencumber the painting from its fiction, to offer up to it, to tender it this suspension *that it cannot support.* This *belt* drawn around the body has to be loosened.

≋

A loving memory on the withdrawal of a surface of the real: that too is what, in the wooden shell, just before the rains or the indefinitely suspended wind, Uccello's Deluge retains. Later we have to see how something is desperately arrested, caught in a gridding, ready to *melt,* like a swarm of hornets, a kind of jelly that would soften, two wooden jaws that clasp the skull, liquify, explode the head, and turn to globs.

The painting (on this fresco) is isolated or ceases to transmit a knowledge that would be at once more vague and more exempt.

(we have to speak of the painting, or, more exactly, of the uncanniness of meaning in an angle that cannot be varied any longer)

The painting holds an "indefinite" memory in its network. Thus, there is a minimal differentiation of the signifier overseen by the possibility of being awakened to a sort of biographical stress. It leads a drowned body far beyond itself: the body of another bliss; a bliss always lost for the body here: that palpitates.

≋

Why Uccello's Deluge? (The question always involves knowing what the signifier is, the core that carries meaning, its wheel, and what is precisely *arousing us in the sense of knowledge,* what drives its denial, burns it), because this brutal theater (sends, throws, overturns, and propels square in our face), a theater sumptuously

afflicted with leprosy, awakens another commotion, wakens our conscience of another body, deriving from and prisoner of a minimal bond; not a breath of wind but a kind of thickening.

Neither a hand nor a finger would touch that body: the question only involves the abbreviated, precipitated, and confused *return* of a real body that is not figured here. Where has it gone? Its sudden ascension followed by an upheaval of the head. But still: the painting sets afloat the arc of an immense, enlarged, forgotten, *latent* body;

blind, invaded, extending, transparent on the stress of a fractured image that does not resemble it. This: a stupor that transmits but makes a body of memory endure that is articulated by the most uncanny denial of resemblance.

Piles of intact bodies, bodies turned pallid, fungosities washed over with an intensely shaken memory, cut through by a kind of gaping stare of its bestiality.

On the right of the fresco, an incredible confusion of filth: a washcloth, shavings, dirty, greasy peelings. This weight destroys the body's flight, its transformation into a dream (the mystical step that the chalky statue of Dante puts forward, advances on its fringe—its hands clasped, but that pull up the toga's train—and crosses intact; shit betraying it): a body buoyed up by oblivion, swollen too with a leprosy of memory, that does not ascend, but cracks, fissures, cooks, stains with grease: founders again.

Rennet of memory on a swooned body, its perfectly white belly cast in shadow.

This fresco: a fresh, putrid (Venetian) odor softly seeps into it and dislodges an irrepressible and yet unexpected memory. That this minimal but invaded suggestion rejoins, over an extremely fragile bridge, the greatest commotion of the signifier (used to replace all other commotion, apprising us of nothing else), or what the dream or memory awakens savagely (the memory-places in the classical science of the *ars memorativia* was trying to stake out the real, with the signs of a certain *relief,* with the fiction of an

awakened body going through a step that was recording its passage).

This space is densely woven in the imminence of a destruction of its referent: therefore, the painting inspires the writing of just that (a kind of Latin text): the reserve of the body that is very much invested in it, or the confession (its delirium that *bridges,* but without, however, arching over just anything); it is oriented toward a process of destruction. The painting also induces a movement of knowledge as a motif of resistance, but whose analyzable elements are always very near, and rightly so: in a certain fashion, the painting causes the signifier to *dissemble*—to get attached to the painting, in the order of what I would call a duction of the signifier, that is forever only remitted to the power of dealing with a certain remainder.

To learn, on this fresco by Uccello, right here—this fringe—of the history of figuration: the fold of a toga, nude bodies, scraped surfaces, a liquid base, a flame at the vanishing point, granulations of a kind of hypersensitive skin, a corneal, aqueous, emulsified memory: an immense memory in puddles, lenticulated, and that blazes on its fissure; a return to a flame. An infinitesimal fire, far off, not consuming the body of mythology that floats in its folds, upon its waters, clots of sour milk, congealed fat, that goes along the whole arc of color on a raft. Crosses through exploded eyes the eye of its color. Putrid, expectorates again.

A subject of the painting, a subject of the negation of this loosening of moldy clots of milk in the eye of mythology: the painting gazes at this bridge.

What is this body of color? The ascension of the boat in Dante (Hell: passing by, the signifier is the voyage in the paradoxical waters of memory; here it is the entire safeguard—and on its entire arc—of matter that retains nothing more than a kind of coalescence of water, mud, milk, and wood: body and memory

bloated, pushed up by fatty matter, by water, scenically set and coagulated in the belly of the shell.)

(Rembrandt's Jewish Fiancée: "while waiting, in her flesh, she is seated on a pile of manure")

It is about (and nothing less) setting down again and, everywhere possible, swimming rather brutally through a layered space. Its pipes have to be unplugged. Its tubing unclogged. The drippings of its milk, cracks, shells, fingered eyelashes, cleaned off.

BOCCACCIO'S PLAGUE

And this plague was also ravishing because it went from the sick to the healthy, the way fire catches on dry matter and engulfs wet things in proximity. And the sickness went even further: not only the fact of speaking with or caring for the ill caused the healthy to succumb, but the slightest contact with linen or anything else that the sick handled or used appeared to spread the illness through mere touch. It is an astonishing thing to hear what I have to say; and, if it had not been seen by the eyes of many and by those close to me, I would scarcely have ever believed it to be true. Had I not heard it from a person worthy of faith, I would not be writing about it: I contend that this plague was of such violence in the way it spread everywhere and to everyone, to the one and the other, that not only did the plague attach individuals to their kin but, even still, the contagion spread quite visibly. Once a man's genitals were infected, or when he was destined to die from this infirmity, when touched by another animal not of human species, he was not only contaminated by the malady but even ravaged over a very brief span of time. One day my eyes witnessed, as I have just stated, the sight of the tatters of a poor man, felled by this illness, being tossed onto the city street, and two pigs having jumped on the rags, as they are wont to do, tore them up with their fingernails, then their teeth, and shook them in their groin. After about an hour, following a few convulsions, as if they had taken poison, both fell dead on the ragged tatters.

From these and a great number of many greater and similar events, fears were born about the diverse figments spreading

among those who remained alive; as everyone seemed to move toward a rather cruel demise, the invalids and their possessions had to be shunned; and everyone thought that by acting this way they were procuring a safeguard for themselves (by avoiding all pestilence). And there were certain people who thought that living moderately and avoiding all excess would allow them to resist falling victim to the plague; making up their own brigades, they segregated themselves from everyone else and, once having regrouped in their houses, sequestered themselves in abodes in which none of the ill could be found and where they could live better by consuming in modest proportion very delicate foods and excellent wines; they surrounded themselves with all available music and pleasure. Others, convinced by contrary opinions, sustained that, notably, it was better to drink, take pleasure, and satisfy wherever possible appetites for all things, and that laughter and playful mockery could be a remedy and an illness.

(the man's genitals having been infected or having died; no demonstrative of the monstrous: the monstrous demonstrative is the wave, the fluvia, the clouded body in the text—the limit of the sickened sex as sex—a syntactically uncontrolled passage, of the bodily part, the sex organ, the thing: the appendix, the attribute, the vehicle)

What is unique in this plague, writes Boccaccio, is that the contagion transgresses the limits of the species (it is going to infect other animals in its circle); an anticlassificatory plague, a terrifying and infantile synecdoche of pig-people; pustulant rags tossed in the gutter are taken by pigs, shaken about their jowls and gobbled up. Humanity is returned to the rivulet and falls after a few twists on these filthy linens.

And under this pressure, as if by necessity, the plague was such that those who stayed alive could have begun to live in fashions otherwise than they had had in the past (the plague is what separates history into two halves: contagion cuts through the species, it is *spread* on a soiled rag, on this kind of bridge: what the arc of the symptom describes to every living being. It is, finally, a new paradigm. The historical body crosses through this illness only by changing habits, its *social habits*—the only history of the body as a social body is written in the history of clothing styles).

Michelet, *The History of France,* 4:217–26 (the Black Plague followed by current of mysticism in northern Europe. Ruysbroek).

Quicherat, *Histoire du costume en France* (modes of dress were adjusted after the plague, "They displayed people's buttocks when they bent over"; crossroads of the illness; everywhere it precipitates a change of scenery and of dress. In every account the plague is a theatrical scourge; a scourge in which the body returns upon its social escheat, or reversion, a return *en masse.* Defoe tells of the processions of migrants, of parades that unfurl on geographical maps).

A *raised* aspect of the bodies (the thoracic cage during inspiration): a staging on painting—asking what may be the theatrically painted body, I have wondered therefore about what scourge the painting was painting in order to grasp the body in plague: what skin, what elbow, how many lepers? A skin that does not hesitate but that soon buckles or rises. A body of painting on an *immersed* skin.

Lucretius: the plague is in the body. Boccaccio: the plague is transmitted over the skin, from skin to skin (linens and sheets spread the plague to the streets and gutters). It is because the image goes back with a body (henceforth, of memory. That body thus finally met its sole).

Deluge: an enormously *planed* body. The great lateral movement, sliding back and forth, shrieking of the plane scraping over the surface of the wooden planks. Ovid: this planed or planked body is what also wants to escape the jaws of the monster in mythology. Affection of painting for Ovid: what are the *Metamorphoses?* metamorphosis is an instance of censure in the text. It intervenes (in a figurative, hysterical supplement) in order to defer or annul the penetration of two bodies, like a *censure of the real* (the case of all the nymphs in front of Pan, of the Centaurs, Polyphemus, of the Silenes). It is a production of this dislocated body, of this *supplemental* thing through a story to which painting becomes affixed (Poussin): an ideal solution of Alberti's *Istoria.*

But a place remains between Ovid and the Renaissance for a development of allegory as a historical moment of representation and—probably—a phantasmal condition of the body. A problem of the division of the body according to its objects of desire, according to an initial classification of this "body" as reflected matter (luminous matter) of the libido of objects: two persons exist in each individual person; this protocol of division is reached only by an unclassifiable question, and a question whose allegory is exactly its *deferral:* of these two bodies, which is the one that is the first to taste real pleasure? It is difficult to discern otherwise why we move from the Greco-Roman body to the *ligatured* body throughout the high Middle Ages (one of the answers is its escheating in both law and scholastic theology). Allegory and law as the problem of an obsession with the *anatomy* of the symbolic body.

Thus: what is the *plague?* The plague is also *the fiction of an infection of the social body that allegory does not ponder* (and, above all, because allegory does not ponder the division of the inner body over the division of the social body. It is a kind of space of unification for the theatrical body). The function of the plague thus entails the production of another division of the body. (Thus, here it enters into the deluge: it is borne less by a fiction than through a need to produce the pertinent division on an unwritten representation of the historical body—it *bonds* with mythology, in other words, with Greece; yet, still, Vico's Greece.)

PLIGHT, FEAR

Artaud: the effect of a signifier cast upon the body of humanity that infects: plight, plague, plaster: the body of writing, the symbolizing body.

Vico, the history of civilization, of writing, continuous scansion is represented therein by the thunder that freezes humanity in fear. This fear, theatrically displayed as a *fear of the storm*, scans the historical impossibility of the body to topple entirely into language, to be a body of the signifier (language, he writes, is the

nonsynthetic *intermediary* between the mind and the body: it's what almost causes the animal body to float within humanity).

A question of organizing the body for a painting that does not succeed in making the distinction. Painting and prefigurative division: a division of exactly what material?

The project of a science, that of a mode of division: how to divide *pictorial matter?*

What is the body that is being divided and that is divided like an image—the symptom. The body is produced on a tuff that is neither figure, the copy, etc., but the precondition of the figurative field as the field of the symptom.

The Deluge (and the painting) is a sequence taken in a history that has yet to be written (the history still lacks if not a historical then at least an ideological "turf"): the history of the body, of its symbolization, the body and the signifier, etc., its symptomatic connections would then be: Origenus, Saint Augustine, Saint John of the Cross, Vico, Schreber.

Now we can make the body speak *about its extravagance,* or else uniquely about its historical symptom: the plague; this would amount to the very return of its social and moral escheating; or the body that does not speak is playacting, explaining what a division is, *as* an image, upon the fiction of its illness, of an illness that covers it massively.

THE REIGN OF THE CONVICTS

The cart of the dead, a body clears the mud with a pole.

"Heaped pell-mell, in the same mushy mass, all mutually putrefied"; "moreover, the people themselves deplored the misfortune of not being buried one by one," *from Tintoretto's plague:* "Entire groups of befriended women, of sisters, who cling or huddle together, in an indistinct darkness, in the chaos of livid shadows, *are already anticipating the community of the sepulcher.* Everything is vanishing, becomes blurred, and is dissolved. And, however, certain ones among these sad little figures possess un-

common graces, already from the other world, languid, lifeless traits, of fantastically morbid appeal. Certain ones, in decomposition, are frighteningly attractive."

Nothing of that is found in the painting, with *detail excepted,* but in all of that there is, however, the possibility of this impoverished gaze, of this sententious literature that designates a color, an enclosure, an odor. In Michelet the plague is also a kind of coagulation in the body of the System of Law ruining the North; the system, ruining credit, impoverishes, crumbles, and produces pauperism. Among the inhabitants of Marseilles, all outlandish actors, the *system* is the procession of expiation, the clamor of punishment: when thrown from windows, from upper stories, bodies burst out of their tatters: here and there (in Artaud this vision of idiotic doctors is recovered, of wax dolls wrapped in canvas that go through the city on buskins in order to avoid contact with *bandages*).

Michelet: "In the streets ridiculous and lugubrious shadows prowled everywhere: doctors, in the strange costume they invented, expressed nothing more than the *excess of their fear.* Standing on wooden skids, covering their mouth and their nose, wrapped in a waxen cloth, like Egyptian mummies, they were ghastly to behold."

The body taking refuge from the plague only happens to be a marionette, a mummy, a corpse in a sheath sprung upward. The very painting of fear.

For Lucretius the body is won over by death like a blotter that the statue is staining. That fears to make a false step (the portrait, the statue of Uccello-Dante: what is painted and seized by fear in the painting).

≋

The plague engendered through the fear of shadows: "A little black boy," notes Savaresi, in the evening, in the stairways of Cairo, who "was afraid of a shadow, struck by this disturbance, the plague struck him the following day."

In Marseilles they cleared the bodies away with iron hooks. At Toulon they were tossed headfirst out of fifth floor windows into the death carts.

The plague, Michelet remarks, enflames our imagination and no sooner, in his writing, it is linked with painting.

The painting here, what I am looking at (what pushes me from the back toward this corpse that is scarcely drawn or enclosed in the perspective), is an illness. The effect of a puncturing contagious leprosy, spread by contact with linen (*dei panni*), writes Boccaccio (of the two pigs that fight over the peelings of a human carcass in the gutter), is carried in wads of cotton. The painting in green ochre retains exactly that: this source of the enigmatic body and of the uninhabitable body (replaces the execrated body). Here the painting is giving us an *infected* body. Going side by side with a double floating (what floats is touched, is rubbed up against, refers to itself).

The plague, they all say in a contradictory way—Lucretius, Augustine, Boccaccio, Michelet, Artaud—paradoxically *conduces to theater,* it leads to the picture of the blind body: a film, the body of a rivalry, it is shot (crazed, posted, beating the air) from a change of its substance. The doctor thus is disguised, he wears a nose of waxen canvas, crosses through the pustulation on stilts that make his walk look ridiculous: in every account of the illness.

Thus, a common theme in the story of the plague: the statue that fords the arc of the fresco: it is the walk, on elevated wooden skids, of doctors snugly fit in their canvas robes.

In the background of the fresco, like a geographical map, a whole continent sails on the waters.

"It's the very soul of the plague. In Florence, in Venice, in Marseilles, it was just like that, bitterly amorous. . . . No pity for the dying. Even death was barely secure.

"The grave diggers are overworked, they are going crazy. Violent measures have to be taken, reductions made. Churches are entered by force, basements are broken into, they are filled with bodies covered with lime. Then hermetically sealed. But they soon became filled and stuffed to the gills. The bodies began to ferment, and, more frightening yet, they were vomiting! The diggers ran away."

glisten? graze? a broad stroke, of a feather, on the erected floor, with streaked planks, a body, overturned, unlathed.

a detail, seen under a magnifying glass, of the body: this body (the two beaters) is handled like a wall. Skin? these scratches have been made on the material of a wall; when it ages the painting cannot retain this skin, but its rather fissured memory. A fresco whose crannies I remember, the sections fallen out of the story, Stendhal used to write: the painting that is *lacking* survives in these "memoires," islets, that are still pushed close together, that float *on black*. Or, to the contrary, like some kind of soup, these black scales—inlaid, flecked off—are like "eyes."

WATTEAU'S DEATH

(: Watteau is sad: "sad over what? Above all, over art. He felt he never mastered painting, *not having any knowledge of anatomy, being unaware of the inner workings of the body that produce movement, and transform the outer side in every way.*")

≋

The beater: the wall, the back, a skin that is crumbling, like a wall of the painting. A clawed painting. The body is an undertreatment of these scratches and scrapings, anatomy, in other words, what remains at the bottom of the figurable body, would almost be a slow, massive subtraction, rolling over this stroke, at the claw mark.

(what could we hope to find in the heart of this very unlikely, very impertinent, horror that is yet so carefully displayed? simply the pleasure of seeing. The crumbling that inspires writing; an absurd, gratuitous excess that a pole or a hook brings back: the underlying fear in the painting).

The shadow that contaminates, the excess of petrified fear (all of Michelet's account is about theatrical fear: a shadow falling into a stairway in Cairo).

≋

I know of few paintings of this period that go so far into the depths: a perspective, a wall of color, that is, an *immured* and graffiti-scratched color. The streaks (a kind of madness, an in-

80

sania delicata prevails), which do not dominate the painting, begin the writing—in other words, begin thus on this cracked surface, take over, and then, with the scratch of a fingernail, explode its date of birth.

Behind *the beater*? The black pig, the female hyena (the hyena).

To a degree, what is attractive in the fresco is its puzzle: a figure is detached or detailed, etc., only enough to remove at the same time the enigmatic and disproportioned fragment of another body; imagine this chain of tossed, blind, pursued bodies—consequently, a tearing away from an unknown body. But this is no less perturbing: the afferent detail; the tiny, annexed body (a given relinquent character, overtaken on the field of another body, of an ever more violent body that shows its muscle, extends its face in greasepaint), well, this bit of body is nonetheless there *all the same* (the dogs, the oarsman with the crook, a foot, a beast's head, etc.) driven to signify, to underscore what it cannot understand: the lenticular enlargement, the netting thickly woven over the skin (beware of the painting's dog if you come up too close to it). I get too close, to the myopic point where I can only hear the entire matteness of the signifier; a body seen from such close proximity, that it appears gigantic (under a magnifying glass, skin is nothing more than the wall, opus reticulatum of Hadrian's villa, with craters like flyspecks).

Explain this, what stands out like a ring in a bull's snout: bodies transfusing. . . . In what thickness are passing these stinking, washing, inundated, idiotic, fused bodies? the painting is at least filming these dejected memories: Diderot, *the skin gazes at colors, and most surely touches them.* That is why. An extremely taut painting (not even a speck of blue).

Dante-Uccello's headpiece (a cleaning lady's rag)

photographic details: certain details are very enlarged and the fresco is entirely fragmented: work needs to be done on the painting's detritus. That's enough to fill a book: to see just how this

fresco is in shards and attracts, like iron filings, skins flaked off, kinds of "moltings" that go only there.

It clearly seems to me that in this fresco *what is being figured is not the plague*. But, rather, this illness: (a memory endlessly colliding, in sudden shocks, of another history on the body of humanity—also a history of doctor-actors that play on their distance, adorned with this bird's nose filled with perfumes, musk, and pepper, that create the stage from which they vanish). A history of the vanishment of the medical body: these dolls on the fringe: a history of culture—they are there with crows' beaks in order not to breathe the pustulation: don't let it go to your head— the only body removed from the agglutination.

From then on the painting would thus be the effect of this fear, led quite exactly to this point where it collapses. Like the little boy who leads me by the hand up into the dark corridor in order to show me, in a kind of bare maternal revelation, that *there* is where he is afraid.

The painting thus inspires me to write about something that writing *sees:* the gaze of writing is thus the knowledge of a fear. I say a *child's fear* since it is easier to remember succumbing to it because, today, a child's fear is the only thing somewhat of the same power. That topples. It's as if Vico were saying: children are afraid of the dark, but they are not afraid of chimera; it's their only way of saying that they live *absolutely* in mortality, without a very little fringe, plunged into this terrible test tube with a pair of tweezers.

If therefore the child leads me by the hand into a dark passageway in order to tell that *there* is where he is afraid, no sooner does a shadow of a rhomb, a spinning top begin to shiver, chest inflated, its head somehow beating its wings.

A baring revelation torn away from this avowal, from this secret. How can these shadows be pushed back? What bridge?

The painting thus leads to the heart of its obscurity, leading us by the same hand.

THE ANIMALS

The deluge implements (in fable, in painting?) a rearrangement of pieces. An articulation of a space on which sociality would be established less than watermarked. Here the matter of the division is excepted; the body that is changed in the story is an experimental body. The only one that is subtracted is Dante's. A body of knowledge, of a paradoxical crisscrossing of painting and of fiction. But the fresco also contains a flaked, desquamated, brownish body, of the color of the stool on which it is seated, as if it were on a butt of wood. A body that gazes at the shadow of its simian body on the wooden planks. Here all the figures are immobilized under their weight, simply dumped where they are.

The animals are details of the painting: or else, many species raised up, written otherwise.

THE LETTER P

We have to imagine the scansion of the text over a gazetteer: petrification, painting, pantomime, plague. But the idea of an alphabetical selection falls short; as in every taxonomical decision, the selection collapses onto its own project (every taxonomy is a project that never lasts as long as the pigeonholing of pieces): just as the fresco does with terra verde, the text would be written with only one letter of the alphabet—under the jurisdiction of one letter alone—thus equally: Paestum, pestilentia, pandeo (bracchia pandit), puss, powder, plop, Poe, pedestal, pick, pediments, psoriasis, pityriasis (a condition of eczema accompanied by a slight desquamation of the skin), planks, plumbing, piano, peat.

The text, like the painting, like its vision, is built around an enigmatic object that floats best in this Deluge: the letter *p*: *p* like the plague (memory), *p* like plaster (biography), *p* like pyramid

(Nerval), *p* like petrifying fear (memory and symbolic law: Vico and thunder), the mazzocchio: Uccello's body, the island, the mouth; *p* like a plane inclined (Varro's man).

DECLENSION

Why is the Deluge leaning? Varro had the habit of writing in his grammatical fragments that the image (and possibly even true matter) of declension is one position of a man standing in language, or on a *tongue*. And that this position was first of all that of the word *man* in the Latin tongue, like a needle turning in the grammatical circle. Or else, himself turned like a fingernail on paper, it would inscribe in the shape of a crescent, ridiculously and fearfully, the history of the human species: the theater of the species, putrefaction, coagulated powder, waters, plague. This minimal fiction of a body that turns and varies, that is pulverized only because, first of all, it is only a word that retains nothing more than this: its minute and hour, the sundial, a machine that writes only one word, that has turned into a needle, a stylet, without any hand.

There subsists, however, this leaning body, from one angle, of a slight inclination (this body that no tongue or idiom would ever possibly redress: that would never tumble, that stays right where it is). This bias has its hypothetical and enigmatic analogy in grammar: for Varro, an imaged fiction of declension: the declension of a body in language can be written on the induction of an outline (of a spatial sequence: the transparency of geometry for Dante before the point makes contact, the twisting charcoal tip that would write it out), the dial on which the word *man*, set vertically, like the spoke of a wheel, like the shadow of a stem cast on the sundial, moves as it falls, attached by its feet to the center of the time and surface of the world: with the same movement Varro's man moves through his conditions in language, through his ages of life and over the surface of the world.

What Varro's metaphor makes legible is not the scattering of the terms of a declension, since this variation of the paradigm in the idiom, or tongue, is illustrated only by the sketch of a metaphor—built over a network of figures, the extended metaphor obscures, *loses* its annexed body. To the contrary, it is the new

body (this *man* who varies only by leaning over his wheel) who *is illuminated* toward the wrenching of his purely positional phantasms in language.

And upheld by this grammatical gyration of his body—while, surely, grammar really holds no body—the image seeks (and is thus constituted by) the "phantasm" of a position or a foundation in language.

The image thus remains this metaphor taken *in reverse*. But, if it is immediately impossible to get back to this metaphor (there is no ascension on the body of the signifier: or else this ascension that credits the diaphanous body with a signifier of election is a mystical step, a floating or slipping step); here the metaphor refers to the enigmatic terrestrial body, a sanction of its intelligible limit. The new body is sent back without the slightest resistance, like a bullet, to the very darkness through which it navigates, to the forest (the fact, in a triple stasis, as Vico says, where language is the nonsynthetic intermediary between the body and the soul). What is also affected in the passing of a *stroke of light* is the very image (second basis of the same *man*), or figuration, which shoots a linguistic object, a tiny unit (the most mysterious, this "homo" on which the memory of the species alights) out of its functioning in order to have it move about the ideal circle of its variation. Of a somersault, a pirouette (Cyrano's fiction, in which he jumps about on a pogo stick, bouncing like a little monad); this word is staged by its own movement as soon as it is isolated by its own passage through language, by its differential character.

Varro's text on the phantasmic resistance of a functional metaphor (as if the text were writing the decline and descending course of a single word): in its leap this metaphor takes the amphibolic body of the linguistic subject and causes it to turn. "Frozen" language is what explains the image of variation, but the image does not in turn move only toward one more improbability, since its improbability is above all referential.

Why is *all of the Deluge* leaning? The two wooden basins, for example, like a book that is opened underwater. It's Varro's man "that no tongue, or idiom, could ever redress": Greek declension in the deluge; it is perspective *on* the plane; neither its impossibility nor, quite entirely, its archaeology; two epochs of geometry coexist in the same space.

OVIDIAN

How do we see? By a return, a sort of wrenching *into the history* of the very anciently captive body of mythology. To the point where this gesture and this wrenching carries in one thrust the imagination of a prehistoric matter. Or its "lesson."

What does the body of mythology simply bring forth? What simply comes with it? More fuzzy memories of very old schoolchildren?

A body that is not made of skin, bone, and blood. But that moves ahead only by wrenching with it all of the indistinction of the raw matter that illuminates it, in which it takes refuge, where it is (in the Greek and Roman texts in which we learned what, first of all, happened to be the declension of the body in the poem), terrified in the middle of the forest, nailed in full sunlight, pleated over by the winds, wrinkled by whitecaps, in the undertow of pebbles in streams. This ostensive sylvan body comes to us only through writings in which the classical age has taught us to *imagine* painting, only by bringing along a forest, feet with straw stuck on their skin, enturbaned with branches, and even more: strident cries like blocks of stone catapulted against the tempest. A body like this begins to travel in history, at the very edge of writings that mark this extraordinary physique, only on a procession of terror. With this step advances, and hammers, on an ancient ground, a sort of bending in the trunk of myth.

A body reduced less by this apprenticeship of fear *because everything signifies* than, rather, being terrified, spread about, hanging onto all of the space. From the first piece of knowledge that prolongs it. If it advances only by tearing away in its path the ocean or forests, it is because of simply being shot through by the incommensurability of a bliss that cannot distinguish its material form.

What remains of that among all these objects? A new and deep fissuring that splits and flows down and away: probably an entirely different violence. Different in appearance, that retains this: that a body is what a form of knowledge inevitably *crosses through*. From this ancient step, and from this very fiction of the panicked, sylvan body, a force of the gridding of matter returns. Between Varro's man and the step of mythology? United in these

two forms of stasis in Uccello is the slow motion of their decoloration.

The degree of the bodily terror, the kiss and the embrace of shadows, their disequilibrium: it is all tipping on the red boards.

The limp bodies piled and folded over one another, pushed into the liquid mud, in this slimy matter that serves as a ground, of the floor sticking to a corrosion on the spot, to the rotting at the base of the mythological body. (Something thus happens here to the body of mythology; something that the iconological immobilization of mannerism will no longer produce by being pegged to the Ovidean corpus.)

BARBARITY

The Deluge is thus in its manner a painting about barbarity (with its storm and its colors it is the other figure of Vico); but nothing could be further from the costume dramas that the seventeenth century puts forward when it stages historical scenes in travesty on the narrow theater of its new culture.

Here, to the contrary, we have a knowlege of the body reduced (of its isolation, of its being segregated, away from the warmth of the flock) in history.

A revelation of what painting is as material in the knowledge of its historical position (posited in its mortality).

In the same sweep this fresco retains something that moves toward writing, and right onto its promontory, as if it were the last painting of the world.

THE BODY THAT RETAINS US

A dated body but a monstrously childish one. A body that surges from the bottom of painting, that spills from the holes, from the casks, from the waters. Teetering, decayed, and pyorrheal teeth, wooden gums of reddish, chestnut, brick. Baring of the stage because it encloses bodies whose every condition is almost at once an indistinction, a mixed mass of positions, of heights, of levels, of proportions, and also an uneven theater: two giants (those who are engaged in combat).

The text has a mute witness (the one that interrupts it): biography—and what if, today, this constant battering that comes from

without were making its own voice audible? making audible what *impedes* it? Death? Obsessive fear? What does the text see right now? perhaps uniquely what it is unsure of writing and the fact that this painting is displaying its body. But which one? A body, here, that is asymbolic, at once hemmed with light and its own remainder. Here the body is nothing more than the effect of *light* (a sort of compromise of white, ochre, and cream) in the Deluge. The deluge is thus what allows to remain of the body, as a body, as no more than a light traversed, screened, and effracted by a filter, through a chickenwire grid, but only as soon as color has vanished. Figures washed over by rain; feint (realism?) of a sort of erosion of painting likened to the erosion of water. The body is the effect of a fiction of the deluge, an effect of a cutting light (calculated by design) on a shard of matter (upon a kind of mist): the body of a cloud that takes flight up from the arc toward the vanishing point (a kind of child-cloud running toward the eye of the storm).

None of these bodies has ever been stationed in the painting; we seem to witness a strange unveiling of the figurative body in the middle of Christendom: what does it bear? Nothing. It is a cloud of mist, a fold in color.

A sudden unveiling: that, at once of catastrophe—the deluge, the plague—that brings to light its inconsistency, its division (the image is never, in all the history of its theory, that is, in the identity crisis of the logic of the predicate, anything more than what expresses not a resemblance but a division) and makes "appear" [*paraître*] a "grazing" [*paître*] (like a flock of sheep) its archaism: its memory, in other words, its pagan reason.

EVERY BODY IS NUDE, EVERY BODY IS DRAPED

The skin of paganism, in the prehistoric catastrophe, that crumples this piece of apparel on the imminence of a rupture of the whole social and sacred fabric. What remains is a fold of fog (but a milky fold, a fold that defecates, that suppurates, etc.) coagulated in light. An exact measure of what is undone: a phantom.

That is why this entire body *is*, is called: the plague. Because it signifies and does not compose (does not combine), an imminent

body on a sloping face of powder, of water, or of a simple contrary (e.g., one of Fra Angelico's faces).

This body is the dermal effect of what its memory would be (but it too has carried off in its memory): what in painting has remained of the vanishing of local color. At this cost (with this added loss) light has invaded space: the plague.

THERMAL BATHS, LAUNDRY

The Turkish bath: a hairless body, entirely shaved (with a razor), bathed, then enveloped in linen; the thermal baths, the steamrooms, etc., Montaigne's "baths" in Italy; Petronius: the *fullo est* bath, a pressing of thick towels.

Dante exits from the thermal baths, in a spongy toga—droppings of the body, toothpicks.

More than any other in the history of painting, this fresco (with an abrupt thrust of the elbow, Uccello throws himself away, invents, turns his back, calmly spells in the greatest silence a few letters on the promontory; letters lost?) *is placed in anacoluthon in the Western phantasm of the body.*

(a dry reed, in the fire, unravels, a living wound)

The clothed figures—are draped nudes—glued in the fashion of pieces stuck on the surface, in contempt of perspective. Already in the Battles, the *body,* through the different layerings of clothing, of headdress, stockings, metal, etc., is made from the collage of different planes, of different flattenings; that is what perspectival signs serve to make clear, and to annulate: with Uccello we witness an effort *to superimpose planes upon a "bearer"* (one figure) that is strictly contradictory or not at all contemporary as a theoretical solution to the *workings of perspective.* In the relation of bodies and perspectival elements, at stake too is a heterogenous relation that cannot be synthesized; here the precise function of the mazzocchio can be read: being the perspectival body, the equally enigmatic body as signifier and the body lacking expression (with neither soul nor other, without division). That body is thus the one that the plague cannot touch—the mazzocchio can function in the analysis as the geometrical site of the antinomies of the the body, as passages of meaning in the body (the area of anamorphosis, of deictic gyration, of the initiator in

the painting, as the agent of transformation in the figurative field).

HIDING WHAT?

What is this story of the Deluge hiding, the defection of painting that is opened upon a degree (an angle, a step, and a level) of obsession with the body, of a body without its phantasmagoria: set between a gesture of teeter-tottering and a sectioning of a statue? Here we have, through a slit in a mouth, the body of the underside of all painting, its chemical substratum.

OBJECTS

The cask, the bung, the table leg, the little board, the framing of the paddlewheel, the bridge, the mill (?), the poodle's boat, the ladder, the island (the island is not an object, it is the limit of a classification). The inventory of objects limited to what floats, bobs on the surface, a slight disorder of flotsam, a slight fluttering in the painting.

Deluge: the wind, the hair, the foliage. The ebb of the waters: clouds, cloth, headdresses.

The binary division thus engages a beginning of the classification of species as different folds in the body of painting (a proposition: in painting the body amounts to simply one more fold).

THE ISLAND

In the background of the fresco: *a continent,* a floating land of a restricted, compressed population. Fallen, limp, into the folds of clothing; a nude body streaked under a bolt of lightning, a body sliced in half—tallow and plaster—(this background of the fresco is held by the theatrical stage). A floating scene, anchored on a tree split in two, a mule drinks the waters of the deluge. Next to it a draped body, perched on a branch, passes by, navigating on its wooden base. The scene is framed on this trapezoid that gives an illusion of depth: the only emphatic gesture of the fresco and, simultaneously, its only "detail," the only signifying islet. The *signifying mass* cut away, isolated, sails toward the confines of the painting—this space where it can only be prescribed—a kind of signifier in the question of its minimal or isological unity: the

signifier would be of the "islet" genre. This detail is in itself also a power of abstraction, it runs its course along only one part of the arc (the body that moves, that is separated, that makes this ochre block begin to lean and roll, that detaches it from a single counterthrust, of an applied swaying, from the side paneling of wood in profile on the left that goes as far as the vanishing point). Then what is this island, this floating bloc of ice, that is pushed toward the edge of the sky, toward an ocean of lacquer? The effect of a wrenching *in the pressure* exerted by these two arcs (the right-hand arc, the one that is set in place, crushes the body of a child, arches it): this pressure makes the design work by a leveling action: a detritus of corks is pushed into, swims, or runs aground on the sand.

To the left: *where* does the arc wind up? This wall *blocks up,* it covers up an entire panel of the fresco—commentary is impossible to write: where can the description end? This final point, of an indistinction between the optical and animal, is given through detail. Here the detail is an entire body: it forever remains not an element, a section, but a full and whole body (blown up, lenticulated); the body is no longer, is not yet (a body of mythology), an articulated animal but, rather, a beast that *gains mass* over color (an effect of pleating the same color, the color with a fuller texture): the body in the painting rejects efforts at classification. This staging of color would be isolated in the history of the painting: it is not only produced by directions for use of fresco material—the classification of colors being a classification of bodies.

In the fresco the isle would thus be the perspective furthest removed from the amniotic body: it is a reduced, divided body; this body of a primal swimming is a restricted mass that navigates backward from the space that the beater chases, like a swarm of flies, who catches and, with his club, endlessly hits tufts of leaves on a latticed panel of the fresco, the wood, and the tanning: everything is curried all over, everything is everywhere bathed in tannic acids.

BRUGES

Uccello: colors lacking variation, an effect of this movement: the amorphous beast, blocked on a gesture. Hands, arms, and head

are in a position such that they bring forth an anthological function of the anatomical totality. Make a mass over the color. All the bodies according to their parts (like the yoke of a state of matter) are interchangeable or all touch a point of latency in their distinction as figures. In some way, a prefigural body because it is anterior (in the fiction) to the distinction of an individuation of figures (thematic, allegorical, moralized, psychologized remainders of religous painting). We have to see a level of kinship with painting *with a single personage,* with only one type: Giotto, Piero della Francesca, whom we can oppose to Memling or Roger van der Weyden: and see the hierarchy of differences between the portrait and the general type for Hugo van der Goes (the Death of the Virgin, at Bruges: a labor extinguishing the figurative value of color: blue, linen, pallor, the candle in an angle).

Deluge: a work on the resistance of a wall of color.

Praise of the Mazzocchio

The mazzocchio is thus the only body that we forever bump into, that in fact changes the writing of the species: it is an exception, *except that* it is an enigma. It has thus the power to *send the painting back* to the constant irresolution of its own position as figure. At the same time it is the only thing that might be *apprised* in the painting: but the knowledge of this second embedded object is phantasmic; insofar as it only "figures" upon the instance of a labor that would blur another autonomy of painting.

The purely oppositional (contrapositive) function of the mazzocchio, from this deictics that designates nothing more than its differential position, a counterthrust to the representative determination of figures, thus produces at least one ideal figure of the subject of the symbolic order (it is somewhat its signature-effect). Although it would be improbable to follow the sequences of a narrative here—yet a history and a novelistic era do color this painting—this object indicates the emergence of an element subtracted from the narrative in the fictional material; a sort of acquisition of the painting: the weight of an element that does not figure, but that is precisely and uniquely mobilized here for the sake of riveting all the bodies to the stage. Or else, an undeclinable element is woven into the Varronian body.

An actor and ideal initiator of the fresco, its point of deictic gyration: the only body that refers to all the others, to all the other outer shapes of what a body is; to *figures*. It alone retains the dispersion of a denotative function that applies to the sum of the figures.

The only figure that holds the group of figures together (and that they cannot integrate as an element: it is an interpretant, but a negative interpretant of sorts), like a stopper, it plugs up their "semioragia" (their signifying flow).

This contrastive function thus is based on the imminence of its suppression: if it is removed (the image is also the site of these imaginary, fugitive operations, taken up again, like the production of experimental blinders in reading; or like a crumbling of painting in the way that writing "blinds" it); if this object is removed, the bodies are not only animated, freed, unriveted, but the contrastive degree that this mazzocchio "gives" to the whole is precisely lost: every body and, in their respective degrees, all bodies are states, or fragments declined from this enigma.

It is thus with this position in *contrapposto* (that does not set aside but that also *accumulates* a figural function) that the mazzocchio stands to be as a "figure" of the system; probably the only one, where a system is produced through the play of only one element.

A buoy: the only element that can neither sink nor be engulfed in this deluge.

But then, at the same time, it is the object of a counterproof: it is not because the bodies are of another matter that this mazzocchio is thus excepted. Over all conditions of painting, with Uccello a cultural object is displaced, its artifice stripped by a distortion of its ordinary use: a properly Sadian idea in which a displaced object is not a permutation of things but the displacement of an artifact in the discourse of culture, *since* the latter always hides the body that it is supposed to adorn. With the same effect the different use that is made of a piece of clothing (its being "purloined") is first of all the phantasmic possibility of having, darkly and deliciously, several bodies turn about, and bodies that are *unknown* at that. It is not because it is made of another material (wood, cloth, anatomies being equally deluged by an imag-

ination of detail and a sort of purulence). But it is because, through its displacement, it becomes—for that matter, in a properly Sadian way—a body of geometry: just what subtracts it from the plague.

A contradiction spurred in the Deluge, it is the only cultural object (a kind of overadornment, an object that bears a number of them) that the tempest carries away. The excess of this futility that sinks: the Dome of Florence and all of the old city are borne away with a headdress.

But perhaps that amounts to the same thing: the only body that can possibly remain is only a hoop, that a form of wickerwork (the mannequin—the "little man"—in which Pasiphaë is penetrated by the loving bull of Minos: the only hiding place and the sham of the mythological body. Why were Jesuits not led to hate hooped dresses? Because the wickerwork underneath hid a second body, one that was *shriveled up*?)

FIGURATIVE BODY

A prosthesis detached from Diderot's *Letter on the Blind*, the same object is a utopian module (of replacement) in an impossible quadrature. An *ideal* figure since it is not expressive and is also nothing more than the logical (or even functional) limit of every figure, that is, *uniquely a position*. This kind of kernel allows us to understand what makes up perspectival relief, a classification that turns into a rebus and inscribes perspective *only* in geometry. Of at least carrying upon that a prevarication to the signifier: of dividing it.

Origenus asked Heraclides if he knew well how to write that "the blood is the soul," if he understood what an image, a concept, or what abstraction is: nothing more, nothing less than an obstacle, a homonymy of the real. If the allegorical man is a divided man: who is the one living in total bliss? and who *first* lives in bliss?—since its division is not that of Dioscorides. Descartes: only one gland that is neither stippled nor made of two shells.

The body is thus the object of a kind of syllogism, on this thought of allegory and of the primacy of situating some of it in the body of ecstasy, in division itself.

Uccello? situation of a symptom in history: the same thing as Oedipus, who brings the plague to an end.

A positioning of characters, profiles to the right, in front and in back, profiles to the left: time (the three tenses)— *death is turned toward the three instances of time* (each representation, each "figure" or stasis of time, is a representation of death).

Only one object in this Deluge could not be infected with the plague, in other words (Saint Augustine quoting Scipio of Nasica), only one body without a soul could not thus be affected by a primal division *on the basis* of a recurring or ultimate division of the inside of its mind.

Mud, Powder

(Artaud: Letter from Rodez, March 7, 1946)

"it is because the race originating from the sexual earth of the Amalecytes, a humus of death through a humus of death, the anal larynx of putrefaction, and that in history left the earth in order to become pure sexuality, no longer of the earth through a humus of willfully amassed and compressed dust, not dust but animate beings of little bones, that has left, I say, the earth in order to become pure sexuality, an incarnation beyond the bones, and being nothing more than the moist hole that in its placenta of wet mud is restored by moisture, a liquid micturition of an adiposity, this race that made Antaeus forget his origins in pure powder, in expansive and animate powder (that if it is always somewhat moist it is only through its dry nature that the wet is detached from it), and this Antaeus, who took himself for Gerard de Nerval, wished to avenge, but pressed like myself or yourself, reader of this poem, reciting or declaiming, pressed by the demands of things, thrown down by the dictature of things that the monarchs of celestial fables have never ceased representing, he was taken and plunged three times in the waters of Cocytus and, without wishing it but being pushed ahead by the old, oblivious atavism of his unconscious, he always continued to *protect* his treacherous mother, the Amalekite, who takes her uterus in order to be and who turned the uterus into his god. And by one uterus through another she is grown to be and to hold in this prophylactic coffer the genesis of her son the god" (Antonin Artaud, Lettres

95

écrites de Rodez [1945–46], in *Oeuvres complètes,* vol. II [Paris: Gallimard, 1974], 200).

≋

Here matter is about its apportionment and, in the very mode of its division, its *mythological matter.*

The plague, the fear, an effect of the signifier:

"I believe that the spirit who, for over a century has been declaring the verse of hermetic Chimera, is this spirit of eternal sloth that forever—before pain, and in the fear of nestling too close to it, also of enduring it too intimately, I mean in the fear of knowing Gerard de Nerval's soul the way we know the bubonic pustule of a plague, or the fearsome black spots on the throat of a victim of suicide—has taken refuge in the criticism of sources, like priests in their liturgies. . . ." (*ibid.,* 187–88).

THE MOUTH

Mouth of painting: toothless, emulsified papillas, letters that become the teeth of the text.

Petronius: Seleucus tells his story: *Ego non cotidie lavor: basiliscus enim fullo est,* the bath is a type of smooth powder over the body: *aqua dentes habet, et cor nostrum cotidie liquiescit,* as if the water had teeth and the heart, day after day, liquifies.

Tacitus: arriving in the rebellious regions, Germanicus receives the osculus, the kiss on the hand that swallows his fingers in order to make him touch the scurvied gums. The body of the soldier standing on an old man's mouth, of a baby monster, a mouth with breasts, a milk-sucker. Obscene swallower of cocks on its knees, a theatrical gaze in front of the prince, sent away like a puck on the hopscotch board in Petronius' dinner: and, as far as I'm concerned, says Seleucus, it's as if water had teeth, the checker squares make the heart melt under the feet of powder, a bar of soap is reduced.

The fresco is thus here: a mouth opened on a tongue dotted with tastebuds, a lagoon of saliva, crumbs, bedsores, detritus, a ring snugly fit on a giant's neck. A ringed body (apportioned from this flesh, this meat floating in a mouth). A stinking breeze and *cut in two.*

Swimming, spitting, right down to the bottom of the throat, a color of oysters. Bloated babies. Dirty rags, a body swayed in the bathtub as if in a rocking chair, its feet sticking out, a cunt belly, the cheeks of a bull's ass, a big woman seated in the foreground and along the cutting axis of the fresco, on this cow's ass, its butt well clefted, carefully fluted, all the folds set in place in order to rub against what she is offering, in a pleasing way, with her cow-haired, daubed cheeks below.

Tacitus: learning of the revolt of the legions, he departs quickly, *obvias extra castra habuit, dejectis in terram oculis velut paeni-tentia* (the legions had downcast eyes!) *Postquam vallum iniit, dissoni questuus audiri coepere. Et quidam prensa manu ejus per speciem exosculandi inseruerunt digitos, ut vacua dentibus ora con-tingeret; alii curvata senio membra ostendebant* (and the others displayed their limbs twisted by their old age) (*The Annals of Tacitus,* ed. Henry Furneaux [Oxford: The Clarendon Press, 1896], 226.

THE ENIGMA

In the plague, no volutes, no relief, a powdery texture in which the body is no longer represented. It is simply *pushed,* collides, a soft and white butterfly, the powder of its wings, a powder puffed from far away, through a tube, across the tempest. And how to make all of that hold together.

A thumb stuck up into the currycombs between its bristled teeth (a mouth with the teeth of a comb holds a few mollusks, woolly crabs).

The scene hence contains at least this: an open mouth, wooden gums, mushrooms on the tongue, the enflamed, torn uvula in the background, a few salivary bodies and the rest scraped, planed.

Right where it is not figured, death is set in an enigma. The enigma is not deposited in the painting in the manner of an allegory. To the contrary, the enigma *frames* it. The painting deals with this remainder. In this way the arc of the painting is a bridge that it uses to cross back over the whole enigmatic arc, it *frees* it, it is oblivion: a tear or blot that brings forth the symptom of a regression. We have to see how Uccello works on the men of the painting. To the inverse of the decor of the deluge, no anatomy

passes through perspective; hence it is there by other means, and that is why a monster hangs onto it. This hanging monster is the possibility of its comprehension or the suspended future of its reduction, its occident at sunset. This body is thus something between the painting (the wall) and the mazzocchio. Here is something that veers toward the painting; something here that does not exist, unless in the kind of imminence its bestial illness confers upon it. The body not recounting or narrating, is declined as a symptom; an organism whose production would make its causes *swoon;* it would like to know about how to "lose" them. So what has the painting been good for? if not to make the remainder incarnate, on the other side of the social escheating that strikes the subject in its flesh (in its being forever guilty for the group).

Unchanneled Waters

At Florence: evidence of a *giant painting.* The fresco: the opening of a sewer, the *fogna* or culvert (clusters of mussels cultivated at the mouths of the sewers of Naples; Venice, channels with walls decorated with these black pods, long beards of hemp: a night is hoisted from the other side of the canal sunken in the waters, scraping its thighs with dirty knives immersed in swarms).

A painting *thrown topsy-turvy* (bodies painted on inclined axes, the Varro paradigm).

If the text that we can never know how to write could be a notebook of sheets uniquely sprinkled with commas (rainfall, a scansion, the chance of an ultimate writing, a script that cannot be translated, incommutable, simply there as a network of cross-hatched lines in streaks; oblique lines on paper, reduced points, emerging from several depths of field, from the volume of the third dimension—lines that by diagonal means would lead only to the dotted writing of a book? But writing the third dimension is tantamount to commenting, deciphering, "watching over"). A book *returned to the rain.*

In Uccello's Deluge several general contradictions define a *frame* of figuration; thus, we do not have—even empirically— either a solution or an attempt to resolve the figurative process in the ways it is thought of by art history or comparative history (arts, sciences, etc.).

An approach to this question would probably begin with the observation that there exists a field of experimental differentiation (figuration, painting), but that it is based only on a summary presupposition: of the homogeneity, or continuity, of this figurative field (on its propensity to expand); such would be the implicit hypothesis (the *support*) that is used to ground painting *crosswise* (but also "through contradiction") of the figurative order (this "order" presupposing a general field). This contradiction of a generative supposition on empirical practice, *open* to its process of transformation, this *dialectical* contradiction, is shared (or: is common with) that of classical physics *as* a science of space (space—and first of all, *imaginary space*—therein is always continuous for a system. Until, in the analysis of light, refraction is the generic given of reflection; until the law of universal gravity, in other words, until a law of differential gravity of fields can be either possible or conceivable: Newton, Leibniz, and painting).

(perspective/geometry)

THE BODY'S PLACE

The nontheatrical, nonscenic body: an obscene body, which floats in relation to a spatial organization, for example, that would be one of its simple vision *or* of its rememoration. A forgotten—obscene—anatomy.

All that had to remain concealed, but the curtain rose on an unexpected theater: that of a kind of illness or mythological suffering of a body, here, that is being attended only by the signifier, whose gap it must assail. Thus, it happens in the deluge to fill the stress of the signifier, left open by the impossible effectuation of a meaning simply conjectured. Very oddly, the sacred place of the face is taken otherwise, the face now having, in some way, indifferently *slipped* everywhere: the work of the facial figure is evidently a kind of facial slippage, of decoloration (imposing the idea that the body, the face, clothing are in sum the slightly swollen condition of a single color).

The theater of the plague (Scipio Nasica).

The mouth: Salacia and Venilia (*De Civitate,* 8:xxii): Saint Augustine writes of the illusory division of the soul of the world.

FATTY

I went back to the Green Cloister to take measurements of Dante's body (about 5′ 3″). As for the rest: bad lighting, blurry effects, rays, streaks of shadow; improbable colors, a kind of lingering monochrome.

In sum, descriptive whorls that cannot catch hold of the painting. A dark lighting: a first film where a commotion appears, that hits me right in the face, with what had to be understood as the *invention of the signifying body:* something as barren as this meaningless, painful, embarassing, stubborn comedy (*Good Night Nurse*). This double chin that in the movies unwinds Fatty's face, dripping with rain, that reveals its *cinematic absurdity;* the crackle of wet matches that are supposed to light a soggy cigarette (a collusion of this pasty face of a fat ephebe with chubby, cruller-like ladyfingers): the same thing; the invention of the signifier in cinema unwinds a violence: that of the absurd body, that of an exempted real. A body (in a screenplay) *pursues* its exception and takes a brutality for granted: that of improbability; that—what it chases after—is what drives it, *that* is what causes it to stumble, to turn like a cord, pivot immense planes, tip, and somersault. Scenario and position of a bit player like this: a sum of pirouettes, the twisted wire where feet are taken up and that attach to a series of objects in impossible positions: but only one violence, the signifier. Holding, retaining a mushy face.

That face comes forth only upon condition of my seeing this painting: a condition that is thus, properly speaking, foreign to the painting, and that would possibly only be the invention of an entirely originary signifier (see for example Varro's etymology of earth, *terre,* as "tera": it is, to be sure, not just *that,* but nonetheless it is *the same thing*).

THE STORM

Something presides over the meaning at the site where every body is sunken, painted, mixed: it is its color, "mired here in the muck and waste of the world"; as if all gestures of swelling, of tearing, were attempting to scrape away this layer of scale: its fear, a kind of skin that confines it entirely to the species. The body thus dreams as if its head had neither skin nor helmet.

A fear the storm engenders (the whole scene, cast under this sulfurous hue, illuminated in a flash, by a stroke of lightning; a lightning bolt that would spread over the sky, that would not extinguish. A body in the background over a slowed, fuliginous plummet. A body of cotton or blotting paper, in a wooden basket.) The fear then is merely what governs the species, dividing animals over their hesitation.

Rodents

"as my horse moves ahead, step by step, along the crest of a tilled field, in my own depths a cave is filled by the agony of rats. Everything was inside of me: the fresh and heavy air of the cave, the sweetish and strong odor of the poison, and the stridence of cries, desperate gallops in all directions; the frenzied search for ways to get out, two beasts that meet in front of a sealed fissure." With what art Livy imagines the hours that precede the destruction of Albe-la-Longue? people who wander in the streets that they will never see again, who bid to leave the stones of the earth. "That is what I bore within me, and at the same time, all of Carthage going up in flames."

(a cave is opened in me, with the agonies of animals: Carthage in flames).

Dante's Portrait

The Deluge is only a disarray of objects. Foliages like types of hair curled back—bodies bloated in the clouds; again, striking effects of the body's abrupt subtraction from the mythology and the cohabitation of parts—the body withdrawn from the labor of this torso is thus enormous, unsown, simply fit snugly with a kind of fever that in the marshes accompanies the very long, abrupt, and disordered skinning and tanning that gives it a nudity outside of fable. That here confers it with a *degree of skin* unknown in the Ovidian body: withdrawn from the line of spittle that winds around it, the cocoon threaded between the stones and branches.

A quality of skin returned to the insistence, to the coarseness or the *lifting* of a color (the body here takes on the rarefaction of the color and an impoverishment of the mottled cloth).

A passage of urines, wafts of manure: advances, dejects, laminates, separate sprays.

Uccello with the bony, angular face, but even less: an angled, taut, paper face—a quality of paper beneath our eyes, a dermis stretched to mastic: puttied with the thumb, applied with a knife, stretched with linen, and, then, quickly wound up in cloth, with dominican wool, the whole head with a turban, quickly wiped off, smoothed out and tossed, and then slapped on the angle of the wood: Dante, a paper face on the crest of the arc.

(with a broken swaying of his shoulders, the nude in the barrel emerges, his head underworn like a basket of crayfish).

Thus, a gaze exists that is enraptured with this painting. I am not entirely sure what I'm looking for: surely Vico's color, a kind of arc in the earth of Siena, or monsters? a syntax or other words. What kind of exchange in the writing? Nothing is to be given— other than the experience of my fear. The Deluge? That is what I am reading, but the order and the wording have been changed. Everything happens over a smell of elderberries. And still, the most brutal, naive scene. Tailored to the denuding of things. A plate raised up by a pair of pliers!

An anachronism of the painting, and as if that were somehow floating among the fishing nets, baskets, the barrels of the deluge: space and color are just about as old as the bodies.

A scene of cubism and metaphysical painting. In it the body, however, remaining as a mixed seed, collides with several areas, has several skins (heavily faded animals and cattle). Certain ones are seen under a magnifying glass, and others not. Yet others, made of flour! small, fine, pulverized, and still? hardly granulous, but not granulated either. Under Dante's silky, medieval hand, a priest's, a lady's hand; nothing is touched or felt, not even the slightest relief: a palm in summer. No sooner, right under this kind of body-hand are falling a filigree paper, powdery flour, dust in this kind of uterine tube, this gaping area that sketches an infinitely Leaving its puddle.

≋

——mystical access to Dante's body: Uccello passes into this transparent body, he passes in the filigree, on the only awareness that the Christian text might have left aside for its hero: the only entry, in an isolated crest, of an *awareness of pain:* from then on

the whole scene is reapportioned according to what *produces waste* in the simple act of passing, in the passage attesting to (a sort of wooden plug) the body of suffering. A nose glued, though it floats in the molasses. On the dragging feet of the species.

THE SHIP OF SPECIES

No garden (nothing grows in this *melma*): the only branches and leaves are those that, as he walks toward us, the mythological man's disproportioned body tears away.

His body is disproportioned (*out of proportion;* he is a wind-up toy whose wooden axles and pegs are waterlogged) not because he is either too big or too small, lost on the scale of perspectival bodies—in this optical congruence that would construct him— but because his is a fabulous body (and Leonardo wonders what the *body of a fable* may possibly be: he says it's that of a giant).

Taken in a halo and, nearest this soft roe of skin where it is netted, the body becomes a mass in respect to what is disproportionate to it: a kind of horse taken in its imagination. It is as massive as the leaves it tears away while it navigates, of a size similar to the ocean; given to a sort of effusion from a seascape or wet landscape (the contrary to the Birth of Venus, the very contrary of Botticelli): not a miracle, a diluted scene, the spectators running off under the storm.

The birth of history (an indefinite end in the style of mythology) with a scattered crowd, zigzagged in a soaked chickencoop, puddles of liquid shit, rotten seeds; the first men move ahead among the palisades, in the midst of crates in a vague landscape.

And Dante in the middle, who slides amid the sludge—very fine, transparent, tenuous. A leaf!

The bodies of painting thus begin like this: flotsam at low tide, shards of things, scattered objects.

THE MOUTH, THE GUMS

One of Tacitus' grammatical audacities is especially being staged. Germanicus arrives among the rebellious legions and works his way into the crowd; or else the crowd, the whole crowd, breaks off—it is not delegated, it breaks off, because one fly goes faster than the others, a dusty dog gambols toward the character or

toward the shadows, sniffs around, trots, shakes his fur, muzzles, a mangy, scruffy dog comes forward, crawling roundabout. Like the prince, Germanicus, who is suspicious, and the dog, which snorts, having broken the leash, jumps like a pigeon, miserable, dung pissed on for years, flakes into scales. Thus Germanicus comes to his rebellious, filthy, famished legions in order to re-instill Roman order; walk erect, do the laundry! crush the bar-baric enemy! hang out the wash to dry! dig trenches and pits, *val-lum*! use files to sharpen all the picks! impale! shave everyday, be in rank and file! crawl on your bellies, do maneuvers while bear-ing standards! Thus, he advances, the crowd is dispersed, ex-hausted while on foot: sixteen years of marching throughout the whole empire! not a single shoe withstood the beating. All the equipment was rusted! everywhere mangy mutts prowled about; the legion became an asylum of rabid idiots, for sixteen years everyone in the same soup. Scurvied soldiers. A whole army re-duced to rot. As soon as it advances, the crowd detaches and gathers around one soldier. The only commissioned troop of the entire legion. A Neapolitan. Tacitus invents what follows: he bows to kiss his hand. A terrible actor, he swallows his fingers, and Germanicus wriggles them over the man's bare gums. But Tacitus does not write that "he saw that, he felt that, he understood." Hardly: "ut contingueret, so that he might touch!" He touched that: there is nothing to understand. To touch in the dark, "that the gums were scurvied!" and that the legion collapses on this hideous kiss! For sixteen years dogs, lice, and especially feet, all of Europe is bludgeoned, and in the same misery together. Gums ut contingueret: that he touches! with a patrician's jeweled fin-gers, in this saliva and surrounding the silent crowd, oscillated, broken off with this mouth. What Tacitus calls osculus, the cus-tom of kissing the hand, a toothless sphincter, an anal mouth. The legions' revolt, relegated to pantomime. (Conticuit se tut, tetigit toucha, ausculta. Roads at the border strewn with teeth.)

The same deluge, with a mouth, wooly currycombs that swim all piled up.

THE WHOLE SCENE

"The most calamitous and fragile of all creatures is man, and the most arrogant too. It feels and sees itself lodged here in the mire

and shit of the world, attached and nailed to the worst, deadest, and most stagnant corner of the universe, at the lowest rung of the ladder, the furthest away from the celestial vault, with animals of the worst condition of the three, and man goes erecting its imagination above the moon's orbit and tramples the heavenly skies under its feet."

<div style="text-align: right">
(Montaigne, *Essaies,* ed. A. Thibaudet and M. Rat

[Paris: Gallimard/Pléiade, 1950], 497–98)
</div>

The whole scene (that is, however, imperceptible in its detail: everything is less apt to be detailed rather of the order of a "painting"): the monster swimming in his oversized body, just as we would say that he "swims in his clothing."

Taken as a collection, an assemblage that cannot be divided up, a few details (in sum, a few bodily supplements) rise up and away, just as if the painting were shedding itself of a few layers of skin: the barrel, the headdress, the underwear; more immediately than in a fiction, the catalog is the occasion grasped and constantly displaced from a writing that details and pigeonholes things. It is as if Uccello were concerned with knowing that in all this—in this mimicry of a great terror that crosses through the human species because it sees its body transform—with an added detail, with an added arbitrariness, a minimal account of the whole scene still had to be made. A tiny foreign body less incongruous than an already violent rarity; on the most reduced stage every little mechanism is an added uncanny effect, an added violence: such as having the same body wear a turban, a pair of peasant's underwear, and having it stuffed in a barrel like sardines in a tin.

Little by little the fresco becomes nothing more than a sum of moving details that gravitate toward the enigma of the body (the body creating its mass by way of position, its cloth, its table leg, its barrel chest). It thus conveys an effect entirely other than its writing since at this point the painting disassembles the body only by moving it onto a stage, and not into its own imaginary world. Unless, in this way, "trampling the heavenly skies under its feet," and Montaigne's other man, his calamitous and fragile creature, ends up being written in the feminine. This body's displacement begins only through the liberation of an ambiguous

"she"—is this the species' pertinent trait? is it the mark of the feminine, or of a "gender"? Exactly how is the contradiction of that body being animated?

SYNONYMY

What can be written in place of "the body"? death, anatomy, the beast, or animal? "man" is somewhat improbable. A word, like Varro's, that has no synonym. Only one valence.

ONE MORE DOG

An *impossibility of cohabitation among elements,* of fragments, and details works through all of the Deluge. For example, the dog—despite the receding planes—next to the enturbaned face, its head crenellated with waves, of the chalky (leprous) man rising out of the barrel. This kind of stupor, this additional dog, an excess in the sense that arrangement of detail, of parts, of added bits of painting carries away. The dog carries off, as in the square puncheon this sort of fringe that cannot be folded into meaning. Here the detail is incohabitable.

One of the questions of painting (and it is precisely the question of its writing) involves knowing *how* to make divisions in this material: according to a grid? according to figures?

Only one body is enclosed in the painting. There it is blind, all of its skin permeated with clay.

An indistinct form is drawn: a cake of placenta borne like the beetle's bubble-shaped carapace. No less, through the painting, an ancient body emerges: surges forth, trembling (not having vacillated or jumped on tiptoes) an enormous edifice (like hair with crenellations) of splintered earth, a clay miter broken into two and teeter-tottering over fissures.

The beetle's bubble, Atlas' globe, plasma in a cracked crust: its monstrous body, its baby memory that it bears under the rain!

WORLD ENGULFED

In Egypt Nerval decides to visit the world engulfed by the deluge: seashells, petrified wood in its veins, a forest felled under a single gust of wind, rings of reptiles. The residual scene of the deluge (of the end of the edenic world) is drawn into the Nile's delta. The arc

is the side of a pyramid (the pyramid built to resist the enormous pressure exerted by the flood).

Even in this fashion the painting is ranking its gestures: rejection and a violent unwinding; an oiled caress on the wooden surface—thus, of a grain, scattered and then broken open under the stomp of a heel. Humanity entirely afloat or enclosed in the tunnel of the pyramid—a retouched mule that drinks the waters of the Deluge, the punctuated and almost "hooked on" solitude of a dog howling on a turning table. A body tubed with cream, with glaze.

A disproportionment thrown on a strait of land, a kind of exploded anatomy. Shot through by a gust, a very old puff of wind. By writing that does not repeat, that disassembles. Even in Nerval when the wind had subsided.

FIGURE OF THE ARC

At the point where the plague is located, the arc is a cumulative figure. The story has utilized this debris, and wreckage, in order to enclose all the bodies whose civilization of merchants (who had something to do with the transition, without being able to use the *duration* of meaning) would have decided that they were to *remain latent*. In the crowds of the plague-ridden populace a second humanity would thus be put in limbo: precisely "displaced" bodies because they would be the symptom—thus, set aside—of a theatrical infection of the animal body; symptoms, in other words, at the foot of the letter, the product of a moving ground.

The hull of the arc is quite naturally a figure accumulated from the repetition of figments of a crowd of the symptomatic body: it above all retains only the monstrosity of a "reserve," of a sort of zoo in which images are heaped together; the image of a single animal that is endlessly flaking away, being scaled upon every one of its positions in the fresco; and that it therefore is endlessly reassembling. Right where it retains its images, the Deluge is then a surface to be swept away: it embraces the declivity of a beast; but that image is already nothing more than its *color.* The color would thus be something like a body turned away from the site and moment of its position. A changed posture; that is approximately where it would begin.

The plague is thus set in the deluge, as if in the same catalog. In filigree on the spectacle of the separation and uncrossing of two historical bodies: from the very moment that this movement is a stage. The fiction of a site of emergence, of the reorganization of history over a differentiation of bodies and customs (as in all descriptions of modern plagues, a man-bird passes by, a fossil-doctor, a "crow"). This scene of disarticulation crowds upon the theatrical organization that death is organizing—in order to annulate, first mythically and then ideologically, an age of humanity. For example, at the threshold of the *Decameron* Boccaccio takes care first of all to put to death those *who do not tell stories.*

A Shadow

How to hollow out, how to sculpt another material within the perspectival space that is always, additional or elsewhere than in what the wall of the arc indicates or determines (a lathed plank)? A sculpture on this impalpable but charcoaled, tarred matter of the shadow. A body, struck with the mallet, rises up, detaches, cleanses itself, shakes off the embalmer's resin, is haloed or still carried off by the stamping of a black mist. An infernal body with fumes that continue to rise from its pitch. A deathly tar stuck here in the depth of the space, on the island, a body in turmoil, thunder, oddly caresses its legs—rises out of the muddy peat.

The Allegorical Arc

Forming a border to this great anatomical display of the Deluge, the arc would be the memory of the foundation of a first alliance, before which these men would not have felt the hand of the god who was touching them. The one who was fashioning them in his garden; and this dislocation of the gardening, this furrowing of shoveled, spaded, and tilled bodies was drawing the proper, initial terrain of the two registers of the allegory: "man labors the garden in which his god labors him"; his body is being weeded, himself cleared by another hand, thus folded over a hidden side on which he is tilled, plowed, and toward which the whole archivolt moves in transition. What is the etymology of this second earth, of this strange *terrein,* if not the very terror toward which the meaning is bending; and that here sends back between the

two wooden walls the zigzag of a blaze of lightning on a crack in the wall? The arc is thus also the second side that a bodily vault is retaining; and that is here a little walkway arched over the two halves of the Deluge (in the gloss this would be a bridge stretched between the two cities: in the same interpretation its double register would hold this animal as an *intermediary* object between two systems, between two thrusts of the pickax, the real and the allegorical; thus, for this reason, in order first of all to be the transition, the veritable transformation of meaning, the allegory is *an image*).

A staging that unfolds: if these first enlarged bodies have not felt the mortifying effect of the tender love that was infecting them, other than through the etymology of a terror, it is then the scene itself, the double retaining wall of wood that holds back their transition in meaning. The arc is thus the allegory of the bodies: the one that contains all of them. But how is it all painted? The bodies are in the deluge of the discolored wood. What in its turn is the space of the image? the man of the arc is an asymptotic line, the calculus of his figure.

<div align="center">DECORS</div>

Uccello's characters are scratchy, they are hoarse in the material of the fresco: they leave it in order to gaze, interpellate, to bear witness to their muteness. A kind of illness prevails, a clinical illness of the entire body, stuck into the glue of the plaster. And whose silence is only the matteness with which the color is *struck*. Nothing is pregiven here, that is, simply of a selection of figuration: there is no order from which these figures would be defined, or from which their differences would be staged. The whole painting is creased along the edges of a very thin fan of substances; here all the bodies are folded into it. Like a catalog, they lead a series of declensions in a substance—whence the aspect of the relief of embossed color that exceeds the bodies, that holds them up, balances them, in the kilning of the clay: granulous tiles under the tension of an incandescent arc.

This has never happened elsewhere in the history of painting. On this stage something analogous is happening (but at what point?) to the savage dramaturgy of the plague (to its theatrical

encysting in the chronicles). Unless the body itself (that every historian isolates precisely on "tableaux") might, in its gestural burning, feel an urgency of the enigmatic expression (it states that it is there, but it is there as *an excess,* upon a movement that divides it); or might be in its entirety the savagery designated by its symptom: the plague.

The plague is also, fabulously, the bodily symptom of an impossibility of completely civilizing, of isolating the vague site of an orgasm linked with death; from the moment that *death brushes up against it.* The social body is invaded, turned into a cadaver, in which the enigma of the construction of this crest of death and bliss flows back and forth. A fiction retained of a scourge that becomes massive, a staging on an inhabited space.

Thucydides was clever enough (Greek perfidy) to find a cause for the symptom that might also have been, simultaneously, a site: the city whose uneven management that mortified the social body about its political mutism in some way *binds* this crazed expression. Next to the migration of those struck ill with the plague in Defoe, in Michelet, and Boccaccio, the staging is civil, urbane, just as it is in Lucretius: not only because the space of the countryside lacks spectacle—only animals are visible (only the details about the species are designated: dogs, bees, livestock)—, but because such a scourge infects only the civilized body; it therefore infects the body in enclosed places. A dramatic mechanism is needed, with doors, walls, and windows; a space whose aeration is always the product of some kind of demolition; streets, bowels, the place where people shout, where different kinds of merchandise are piled up against one another, little islands through which one wends one's way, corners and crannies where silhouettes bend or break, and shadows cast in several directions at once. Thus, this space is needed, a space that the classical imagination takes to be minimal, with windows that do not give onto space, with contiguous walls, with currents of air. A type of drama written by historians, which appears to be so terrible only because it is staged, on the same platform used for comedy and heroical drama, only one decor that is displayed and that is turning: a kind of tragedy with a door closed, sealed, marked with chalk on the transparent panels, with bodies that

speak no more, that shout, that fall victim to fever (a fever that has no lull, but that is moldy) and that are only gesticulating. Michelet writes: that throw themselves forward.

In another of Thucydides' scenes, the plague is a social illness par excellence: *it bifurcates,* a kind of intersection (an awesome moment, a lasting indecision that becomes gangrenous) in the crisis of democracy, where bodies congeal, are struck with pallor (Oedipus, Pericles). As if right where it had not been set, displayed, the painting were ceaselessly prescribing the invasion of a decor, the overflow and complete extension of colors beyond its animal figures: as if it were being exported on the basis of a blinding of the figures that it contains. Enclosed between the same walled panels.

ON THE ISLAND THE TWO BODIES BACK TO BACK

What appears in the background of the fresco, in the refined treatment of the body that the detail and that the imaginary selection of an infinitely tiny signifying texture carry off (however, no grain other than the spreading out, the thickening, and the cracking of a kind of milky sperm of chalk, of plaster, like a dermis of the painting); what is shown in the depth is still the declension of the paradigm of the two bodies.

Of these bodies set on a minimal public display of their gestures, on a theater almost totally spared by their movements (we have seen, or have known that the plague is the rage of expression over its emptiness, over its lack of content; a forced theater of the body placed on its embers, and on its coals, by simply being there: a gesticulation that cannot strike down its soul on the same stage, threatened by that sort of confusion).

What, then, of the wind, the carrier of seeds, that passes? The bellows that kindles the scenic flames, that continues upward to turn the species around, that splatters their arms to the milky walls, to the pegged boards, sealed with angles, running blindly on the closed walls.

However, there descends, drearily, as if into a well, this couple, these two pleated shadows. Like two hands set on the wall, like memory set in ancient tracks, in a somewhat archaic way one white hand that still wears a plaster glove, and the other, already blackened by lime, burned.

III

Of this body in turmoil thunderstruck and turning like a spindle (but the other, turning in the other direction, winds up the wool, a white spindle; two bodies bedecked with ribbons, covered with threads, cocoons).

But in this sort of well, a ditch in which diving spheres are plunged—swim, are splayed, and clash the Greek twins of oblivion.

Two figures of oblivion like the twins Thanatos and Hypnos: Thanatos the black who has "an iron heart, a soul of bronze, implacable in heart," Hypnos white, "calm and soothing for all humans."

Something of a primal couple (that of a myth of emergence, and that of two types of matter, of the two colors of the whole painting) that is not founding an ulterior opposition, that is transforming nothing—a reconduction on this indistinct, divided point, of a division that *represents* but expresses nothing: (that of the City of God: the story is a process of the differentiation of a structure contrapositive to its "model") this paradigm, contrary to the "acts" of the deluge that the theater of sacred historiography is irradiating, this gesticulated paradigm has no moral coda. It is situated—because it is located so far away and treated so delicately—like an atom of division in the heart of the tempest: the two humanities, the two times of life cut in a flash of lightning; an image split in two by the thunderbolt, yet also the back-to-back struggle of these two contraries *yields only one image.* Its moral is possibly this: we see the return, but especially a scenic return, spliced together on a lagoon, of the double body of Narcissus: Thanatos and Hypnos that the same waters are surrounding, the arms of Lethe, memory and the water of dèath. One has burned.

Where is it taking place? Right where the background holds the painting up, and herein the doubled fiction, of a kind of alternating transparency, slips the plate where the deluge is painted under the one where the plague is painted; exactly right where these two bodies are touching; where plaster creates soot in a blazing instant of contact. What makes all the bodies arch up, billow, swell, and float in the fabulous painting of their wound is caused by these two bodies touched by the lightning bolt from the hell of homeric hymns.

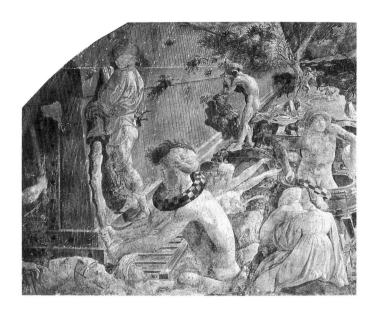

1. The Deluge (left side)

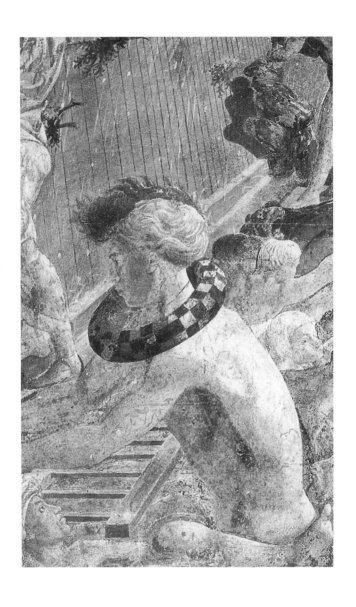

2. The Giant with the Mazzocchio,
the Plates

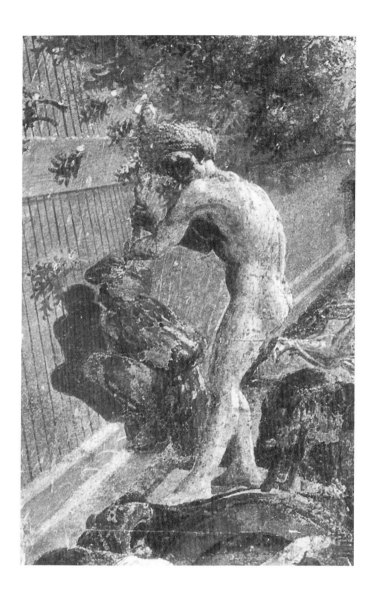

3. The Beater, the Seated Beast

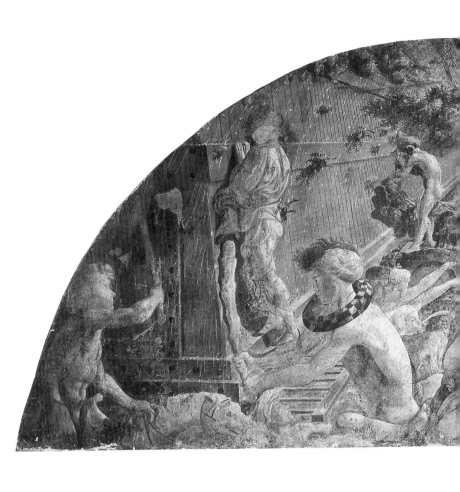

4. The Scene of the Deluge
(Florence, Santa Maria Nuova)

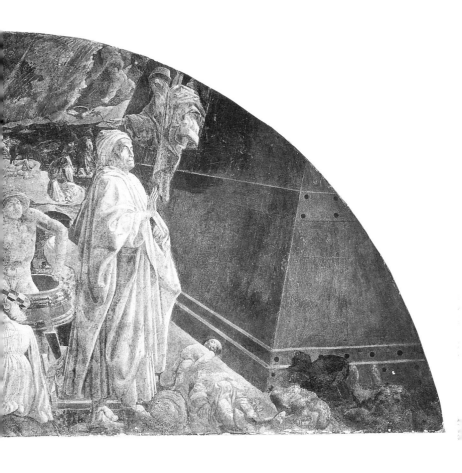

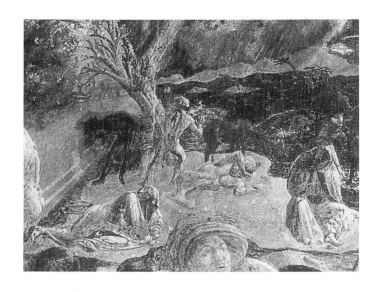

5. Above: The Island, the Paradigm

6. Right: Medea in the Museum of Naples

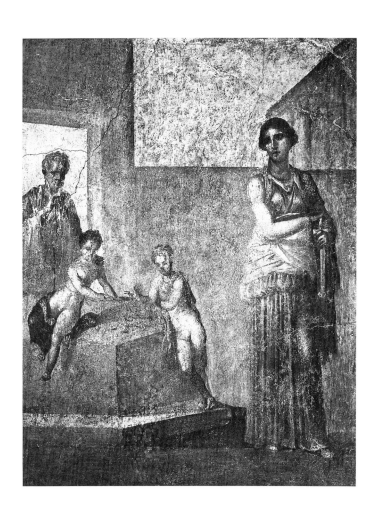

7. The Uterus

Beginnings of the writing of mythology: the whole painting "holding" the painting together here because two bodies, twins, in a spasmodic gesture, are being *torn away* from each other (memory on this body of the image: the body of the image, too, is double; also of this "inventor" of the painting. Of what invention? of what the history of a species acts out on the most tenuous stage).

The "point" of the fresco (like that of a sonnet) is thus not only a childish body but also a bifurcated body. This point is still what the painting uses to invent the history of civilization.

(the two bodies of the actor in classical Rome . . . what inspires travel is not an object, it is a paradigm; an impossible cohabitation of objects. It is even that very impossibility that is *being written.*)

Singular, Plural

An immensely receding aspect of a number of bodies in this space: to be sure, bodies that are larger than others and relegated to the background, moving along a blind wall of wooden planks. But the giant with the mazzocchio jumps around with his club (a deadened battle, a body floating in the water). Only the beating body (the club, the black mask, the helmet made of leaves) plays this role: with only one, overly large animal, from the giant torso twisted by its musculature. Torn away in a gust of wind and resisting the movement that carries him off, in broad thrusts. Why then, only in himself, and on a pedestal, is he written in the plural, with several bodies tossed backward into space: a sunken echo of the battle of clubs but flying away in the wind, that strikes clusters of leaves, like swarms of flies? Then what is the other body fused by the deluge, the second object of this *declension*? The mazzocchio is a round body that is silent when it turns. It has no voice other than the whir of its hub. At once exempt from the deluge, the plague, and the fiction, it is an indefinitely contrastive object that extends its oppositions to every posture taken in the fresco. How can the deluge be grasped by this single piece of Florentine clothing? the floating headdress of one of the women narrators of the *Decameron*.

DETAIL: PUZZLE, UTERUS

Here detail is less the imagination of a texture of the painting than its puzzle, especially a kind of a *flat* being: poorly joined pieces, little holes (of water) and whose isolation, by way of dimensions (detail being a splicing of matter, not of figures), annuls all possibility of semblance (all referential verisimilitude). The operation of this kind of extraction is a common surgical gesture; preparation for the technical study of a texture; it's also a test lacking imagination: where can we grasp a body that is smaller than the figures? does there exist an embryonic degree of painting in which it continues to "figure"?

The artifice of a puzzle: it stands on the drawing of a hollow, on the imagination of a kind of emptiness that would be behind the painting (at once poorly chosen pieces or petals that are not adjoined to one another). Something more than the imagination of a seed of matter in the painting: that of the little gaps from which it is made: bodies are not adjoined, physical bodies are made up of holes.

Thus, details retain something quite exact (here they retain in the square the five substances of the Deluge: water, earth, linen, skin, and wood). It is also an infinitely tiny, tissued condition, the infradistinctive point where a staging of the bodies of substance in the painting is being decided. A point that *has no* anecdotal or figurative role is what verifies a process of subtraction from a figurative order. An upper windowsill that casts light on the scenic indifference of all the materials.

Over a rounded fissure (a figure drawn of uterine tubes) an anatomical view is constituted—but does not cut into any body—of the flattening of the fragments of painting *sent back* to a neutrality of color (to a color that *states* nothing and to the possibility of increasingly flattening the entire fresco by displacing this square, this kind of "reader"). As soon as this lacuna is enlarged, or flairs out, we have the body that is staged and the painting that begins to *represent*.

The whole fabric of the differentiation of species here is framed on an angle; the body of figuration incarcerates its point of neutralization.

In its turn, this kind of uterine tube, this gaping area that sketches an infinitely tiny bordering of the world's continents, of

skin and linen, continues to show, on the underside, that the painting is fused less by these textures than by fractures.

Imagination of what would be a little gap showing at once the depth and a discontinuity of figures in a given matter: a matter that *cannot* figure, that at all points remains, and that in the wefts of its fabric is progressively invaded by the effect of a thrust moving counter to every mode of bodily positioning.

This fracture appears (the skin is not stippled) only upon a point where the different bodies attempt to join one another, to stick in the same space: to be fixed into the design.

Bodies subtracted from all other imagination in the wafting away of pieces in color. Here too there is, *under* this kind of inharmonious splicing, arbitrary cuttings, an infinitesimal pleating of color—an imperceptible diapering—along the edges of a star-shaped wound.

(this round fissuring separates: a wooden plank, the bottom of a dress, sand, a child's legs, a head with a piece of cloth).

Only one character in the fresco has folds on its belly. Detail, slipping over the design, flattening the perspective, is almost the same thing as a form of "writing" in the fresco.

Where Is the Painting?

In Varro the color, body, the etymology, and clothing: "*Terra* is written *tera* with only one R in the augural books because the tera is what is *teritur* (trampled); and clothing, *extermentarium*, what is worn (*teritur*) by rubbing the body." What is clothing? the proximity of a piece of fabric, of the earth and of fear, of a sort of *rubbing away*. To that clothing that has been somehow *tread upon*, to this piece of clothing that is exactly the one thrown down by the crusher in his path, we thus have to add terror, teritur, tera, the other chain of fear and writing of the word *terrein* in the *O.E.D.*: everywhere only one color.

Mensurations of the Arc

The *De Civitate* establishes the mystical measures of the arc (and it possibly establishes them in its entire project—in its title). Now this calculus, as with every numerical manipulation for Saint Augustine, amounts to nothing. The deduction, the com-

bination, do not produce, in the same regularity and negative monotony, the slightest *serial constraint*. Species, articles, or allegorical members thus affected by numerical indices are simply isolated or subtracted from all other interpretative summation. The body set aside is thus a body where an account has been made, that a calculus has happened to erase, to sand or plane down some kind of monstrous projection of the signifier. The calculus in this way yields only the effect of a cipher: what can only be one more sign of its allegorical echo. A reiterated sign that encloses and perfectly isolates several bodies in the degree of a species. This labor of numbers is not work done overtime, but a clean-swept whitening of signs: the body enclosed in the mysticism of numbers is thus washed clean of a flow of signifying force, but also a body returned to its insularity on one degree of meaning. In order to make the case for a perfect accession to the sign, this degree is uniquely "set aside." This little island that the calculus is pegging is thus detached from the ocean of words—signs that in the Augustinian text are only moments of flux and diacritical bearings in a great topology of meaning. Calculation is therefore made upon the signifying material or species (the word, taken in an interlinguistic dross, an amphibolic scoria) the operation of abstraction: it is an operation whose effect is only that of showing what it excepts—and what is properly a subtracted unity made as meaning demands, an indifference of selection; of yielding only *uninterpretable* members. A body exactly nourished by the loss of multipliable meaning. That does not quite amount to the "exception" of meaning (for "discretion," as Catherine of Siena would say) that constitutes mystical meaning. (What effectively is mystical meaning? It is a meaning that *cannot be located* in the typology of the four senses.)

This kind of aberrant calculation, by which Saint Augustine is assured that the dimensions of the arc can correspond to those of no real construction, thus yields a *probable* figure: a figure both singularly set aside and recurring: the arc of alliance, the City, the body of the Church; it thus gains access to the city of Diest, to the lair of the sibyl. Here the mystical body is more or less nothing other than the effect subtracted from all means of proof (since this sole proof could only be eschatological), of a mensuration of the *body of the fable.*

THE WINDOW

There exists a fictional, impregnable, and vagabond body in the whole of the figuration. That is what, in passage, is *grafted* onto the image, and not the other way around. In passage, that is, in the time its writing expends: somewhat as if glosses had to be established, notes taken in a material that is vanishing. In this way a window is opened inside the text: Uccello pushing his torso through the window (Noah); all of his clothing descends in folds, like a comedian's beard. His place is almost that of the aging suitor in love comedies. What can he see? He doesn't see the painting (he sees *within the fable*): he would stare otherwise at the bodies held up, as if bobbing in the wind of a bellows or on the inner side of a spinning top; he would see bodies spun and lathed in the movement that sends them spiraling outward. He is only looking at the round bodies, barrels, teetotums, crowns; he is looking at what is, on the Florentine hat, the third dimension, like that of the death's head in Holbein's *Ambassadors;* above Dante's shoulder, the anamorphotic spot taken in a twisting synecdoche, a circle amputated by a quarter, a dial, a gyroscope. As if the entire scene were to change, be emptied, and retain on Uccello's polyhedron only the *place* of Holbein's anamorphosis, while it keeps its emplacement only upon an allegorical, or "empty," position. The history of painting is written through differently arranged windows that always are oriented toward the same point (the yellow stain, the changing point).

THE BIRD

The doctor of the tempest is a man perched on a marionette with a bird, a crow. In scenic terms this useless practitioner, an inept doctor, is a fossil body, a sort of archaeopteryx—covered like Jurassic vegetations, as Freud would say, in the archaeological landscapes of his great neurotic patients. With spasmodic gestures, featherings of waxed canvas, these bodies are simply *still there,* in the order of a recurrence of a dramatic delay; a lag of this king (in ritual, in costume) is what constructs both the drama and the entire tragic staging. Actors drag themselves about as if they were pure forms, characters without a contract, unable to tie into the performance. They have a power, to be sure, and that is

already the birth of the opera over a mechanical, bipartite monster, of linking voice to diction, to song, and to all of the phatic signs of that delay. Moving about on wooden altars with strident cries; the same buskins Wagner used to write as the song into which the actors were being fitted.

A splash of fiction: the opera, even upon this fossil monster, is born only of the delay caused when bodies begin to leave history. How much delay (and even fear) that turns history into a stage; all this, no doubt, owing to a very long and slow liquidation of religious historiography.

The archaeopteryx, this doctor in the plague, is a synecdoche: what separates, what unites, Dante's statue and the crow pecking its eyes out.

THE DOVE

omnia pontus erat, deerant quoque littora ponto. "It is true that Venus had been borne of water; that she returned to it at the time of this deluge, during which the world became a sea, a sea without shores, and that she soon fell asleep in the depths of the water; it would not be wrong if we added that she then emerged, again, in the shape of a dove that became fabled all over the Orient. (Thus, we can only be surprised when men were not led to mistake the dove for the bird of Venus; nothing is false in pagan belief, but everything has been corrupted.)" Such is therefore a look lacking terror, a look that does not learn, but that *follows.*

THE GODS OF THE DELUGE

The deluge enters history in several fashions; it also enters, inversely, into several stories: in religious historiography it could represent the correction of an initially aberrant, disproportionate creation, a corrective polishing of bodies with gigantic appetites; or still, the production of a fabulous anteriority, properly subtracted from all memory, of the body of humanity such as we see it now; such that, precisely, it would own a history less than a process of aging; as if, following an immense parabola, up to the deluge human bodies were endlessly being reduced to bestiality, were not aging but enlarging, stretching out, being gigantified. The catastrophe would be the first brutal arrest of an indefinite growth of humanity, an erosion and an abrupt polishing, a stone smashing down on human fingers.

In preclassical biology and archaeology a kind of beginning of calculus—a beginning of the inventory of newly refined, observable species, but also a beginning of the computing of civilizations, of reigning eras, of astronomical phenomena (since the first is, rightly, this great rent of the curtain, the first night at midday and a gushing of waters whose original level no rainfall could ever restore). The beginning, of which anteriority of the ages of the world would be unfathomable, without a trace.

Outside (or square in the middle) of these few excursions to the past that are easily the laughing stock of the imagination of former sciences of beginnings, another function is being lodged. The deluge is a valuable fiction in the history of religious ideology. Not only because it *classifies* humanity according to the impossible capitalization of its past as a species (of this beginning, of this erasure of a first creation religious ideology and its later historiography have especially retained the moral gesture of a beginning over again and of the reprise of a humanity *upon the*

death of an animal species). But only because it is inventing a paradigm that is eminently susceptible to being repeated and re-produced. Because the very effect of this stupendous caesura pro-vides the second humanity with a body that can flow and be molded over its desire.

The moral or allegorical image of the deluge leads, for ex-ample, to that of the change of age (and of a change that produces history) of religious structures as a symbolic prescription laid on humanity. The turf and the stakes are at once a matter, an enigma, and the theater that assembles them: this stage that we carry with us, the theater that accompanies humanity, is its body. A body that first of all only concerns a paradoxical knowledge, that of the enigma upon which its figure is made. But this very turf and these stakes still remain the history of its imagination. The object in which humanity sets foot, in which it has at every moment been able to touch its animality, this body: is the theater of a knowledge that religion articulates, annulates, attempts *for a first time* to neutralize upon an imaginary anatomy. An anatomy invading all production of meaning: in the first place, allegory is effectively the exhuming of a phantasmic inner body. It is already divined that every production is connected to this allegory of the body. That all knowledge immobilizes, marks its own arrest, on the incertitude of a link with allegorized matter that is articulated less than designated *over its unknown quantity* in the allegory.

≋

What is here, in this painting, in other words, the deluge? A rain by which animality descends, and makes humanity "porous." This fiction leads to a very fragile stasis of the construction of the Christian body *upon* savagery; through its immediate buttressing.

≋

Once again the great ideological actor is Saint Augustine: he only changes the language that is written by altering dogmatic evi-dence, precisely in the order of desire. As if the stakes of such a writing entailed sticking to the radical project of *changing the body*. The emplacement of an insoluble configuration, in the form of a Trinity, this production of an unknown quantity (in respect to

the relation of the substance of the trinity) thus guarantees the *loss of the real* that the representation of a given theoretical "subject" takes for granted. That same representation begins in return, or *inaugurates,* an incomprehensibility of the body: whose consequences are symptomatically borne, and as such, on their *axis,* in the question of the *status* of the image. This trinity hence also serves to insure the body's dereliction. The counterstasis, in the beginning of a very long labor of the escheating of the social body, is indeed the memory that never proves the trinitary instance (in other words, the instance of meaning insofar as it cannot be resolved in a "figure"); it is also the infinite problem, and is solely translated through allegory, of the representation of the body in the name of the signifier.

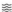

Somewhat as if this religion were based on the idea—that is juridical—that peaceful bliss does not exist; that it always carries with it an animal turbulence; that the body is thus one of an immemorial fault and that it is only forever "isolating," as soon as it is staged, unintelligible characters. As in the case of Roman law, in which there are animal crimes, the question entails purging this animality that is impeding a peaceful bliss—but a bliss of what?

Everything is happening as if the problem of civilization were surfacing again in the "fabulous" modifications (and almost imperceptibly in the symbolic revolutions that constitute changes in religion) and had to do with attaching the body (the one of an age in which: "the soul is difficult to discern because of what has been *added*"), manipulated much more as an object than as an actor or agent of civilization, with social structures of distribution, of production (this body being initially attached to the production of nonmonetary, nonstandardized equivalents, understood in a "vague" symbolic activity). Objects diffracted upon a power of unfathomable, incommensurable bliss that thus *becomes massive,* through altered circuits, for the totality of the social body.

As if the act of culture had less to do with organizing than, more precisely, with dispersing (on social and religious fictions) a

power of self-gratification. If the body were in the first place an erotic machine that produced no symbols. Equally nonsocial, taking no part in any fictions about the structure of civilization. The end of savagery, in which the body is propped in order to be constructed, thus entails distributing over a starlike network its initially asymbolic production. Does the end of myth, or the tail of the diluvian fiction, involve changing the body that has not yet changed its sociality, the body-islet? Antediluvian men: homeostats, closed organisms, folded upon their pleasure, affect. As if every color were crossing through them without overflowing, without being shown; *white* chameleons.

≋

What does it matter in the painting? the acquisition of this bliss of the new body, since the painting (by the very default of what is above all an organizing fiction) is what can dissimulate it in a unity (since its unity is merely enigmatic) and conceal it.

The Deluge? an emerging myth of the turf of a new science (and even of the *Nuova scienza* that is integral only to the turf itself: Vico writes that, as soon as a section is marked off in a terrain, a blazon, an allegorical field, is isolated. But a humus is also marked off, an incision is made in a history, that is, in social gestures).

≋

The same happens in the change to monotheism: the nothing of bliss that concatenates civilizations amounts to nothing more than a renewal of the body.

≋

Each time that the body has to be changed in a culture in order to establish a foundation and a jurisdiction, a great tidal wave ensues, devastating all anthropomorphic representations of the idols. Because these representations are not symbolic of the *production* of a site of desire. Because they turn the human into an archaic subject, as an ideological subject—or because, in view of the gods, it remains the supremely unthinkable element of re-

ligion. And because, *consequently,* it is always *outside of its acts,* the principal unthinkable element of law (Roman law, as we know, is, for example, developed over the *emptiness* of the concept of the juridical subject).

It is almost in these conditions, in these causes, that the liquidation of polytheism presides (on each of its figures) in the *City of God.* The classical gods are monsters, grotesque forms because they preside over the monstrous detail of humanity (from details drawn upon anthropology. And no sooner, anthropological unity does not exist).

The deluge (in Uccello's staging the city of God gazes at the city of men, the one whose back is turned) is thus nothing more than a prologue to the defiguration of the gods; gods that infantilize and, in some way or another, babelize humanity.

Can't the diluvian gods be found in the midst of this redoubtable stasis? There are three of them: the wind, the body of the tempest that can crumble into so many pieces. But especially these two prehistoric monsters that are the two tongues of the tidal wave: within, each movement produces a body, a body that is the imagination of a single organ that throbs all alone.

How, over and through that fiction, can we understand what a body is, in order—on the memory of an experience, that of a wrenching that brings about an excess of conscience to enter under the effect of the speech of the other; all the writing of the *Confessions*—to be able at once to erase and to allegorize it entirely. Entirely with something more, with the unknown that its structure is developing. The trinity—*that the deluge prepares*—is a structure expanding an unknown quantity of articulation; the enigmas (responsible for the order of the definition) are resolved in articulations that are added and hypothetical articulations added to what would be a *transparent body:* a body that would not need an auxiliary science, such as the hypothesis of a network of reproducible articulations of what is invisible (the book on the Trinity is a labor that constructs the *inverted* transparency of the human being outside of *the body of allegory*).

If the Deluge (if any deluge) is the fiction of a new body placed over its symbolic enigma, then why is a new body needed for another conscience? Hence we find in polytheism (every god is

more or less the symptom of an oblivion, of historical residue) an animism of the ocean, a throbbing without the probable voice of the sea; what, asks Augustine, are these waves stirring up? almost nothing. The desert of a fringe of froth, an imaginary hem of the earth and its waters; a hem in the phantasmagoria of another body (Cicero writes that in this moving rim, or hem, we find the *very invention* of law: the invention of a matter that separates and that amounts only to a movable line). Of two ghostlike bodies that answer to no one.

Two names (Neptune's wives) that distinguish a kind of psychology without actors. A physics of the substances of their movements; stirred up under the figures of the medusa is a gelatinous pool, taken solely in the cutting light, a stain of sperm, of slobbered foam, a perfectly empty scene. Drowned bodies upheld outside of them, in two throbs; of which the second deposits the remains.

Thus, there is a vessel, a cage, a floating caisson, a thorax licked by two opposing waves. On two tongues. Enclosed between two oceans.

A fiction of goddesses that have no statues, of Venilia and Salacia. As always, the theologian takes these bodies at a verifiable level in the scriptuary material: *through etymology*. Taking bodies by way of etymology is tantamount to assuring oneself that they can only go back to the entire signifier, that they can only possess short inductions, or bifurcated fictions. The issue thus concerns submitting the writings of paganism (here Varro) to the same technical treatment as sacred writings, but with this sanction of the absence of a level of meaning (the one that is precisely carrying the commentators over their scriptural *position:* the *only body* that pagan representations do not induce is the one that rises up, as a crisis, to its identity upon the transitivity of writing; since the instance of its new truth is exactly that of receiving this hem in a drama, this fiction of a line that inaugurates law, and whose suffering body, that of its affects, receives its "deposition" as a real body; as if the necessity of a higher truth were dividing this organism over the fiction of the productions of objects, over the

instance of their "writing"). The negative moment of the apologetic text still entails submitting an allegorical text to a literal reading: this operation therefore produces (or works through, at its level) a referent that is disproportionate in relation to meaning. A catalog of details, of phases, or of unassailable members. More precisely? *of figures.*

If the new theology only works to destroy the possibility— and, in the treatise, the *probability* of figures: in paradoxical fashion they are hence sent back to mythology, in other words, to a pure catalog of species, to a catalog that *creates species*—; the campaign launched against polytheism thus aims at symbolic pluralization insofar as the latter is not a representation of the *suppositions* of instances bound in respect to the structure of the human subject—that the structure is the exact opposite of the trinity; it is the *prehistoric body of dogma* that is being toppled.

And probably because this plural is not homosyntactic: we know that, in respect to the anthropological model, the virtual reduction of a heterosyntactic type is an inaugural operation of the method and procedures in *De Trinitate.* The goal of theology ("diluvian" theology) is to extend this structural hypothesis universally. The true god is thus (and here is why the Trinity *alters the logic* of categories and the laws of inclusion: a perfect logic of totalities is that of the recollection of bodily parts in the sections of mythology) nothing other than the point of annulment *as the object* of every intepretive plural, and *for humanity* it is the need for an infinite declension of that point. Augustine's topological operation consists in a classification of the levels of meaning (the religious problem is above all that of revealed writing and of its interpretation) that devolve upon the structure of the subject—it is at once a linguistic subject and, in a more general way based on its hypothesis, a subject taken upon the jurisdiction of the signifier. And for the first time in the order of a "former irrational" constituting desire: it is because at that point contradiction is the labor of the signifier and of time—and because every reflection on time is a reflection on the *limits* of expression. The fragility of a new, nascent anthropological subject is indeed this figurative resistance: of also being an image on the moments of its signifying production. And on these angles, which are held in language, of

being lost in the body of the gods of former times. On its own theater staging civil theology, since the hypothetical organization of a trinitary god (as the instance of a union that is an act of signification) also dictates the relative dispersion of a species.

Thus, in view of these new topological requirements, polytheism *can only* topple: it must topple above all because it knows no universal affirming instance.

Now this kind of mythology represents an entirely diffracted body, its dispersion of feeling, that can change no living being, not only upon the hypothesis of its unity but, furthermore, upon the instance of its partition that, recently, is the doctrine of the soul. And how, with a return of the maturity of the pagan body, is the painting divided?

Thus, the stage of the Deluge represents this theatrical position—because it *invents a matter on the meeting of the two scenes:* a matter, exactly of this painting as the site of two prehistoric acts, such as the hem that sews together the two halves of a body of different ages (the imagination of a soul in so many positions and, especially, of *separate* bodies, touched by relative gaps); still, these are the gods, these impotent gods who, as Scipio Nasica feared in the theater of plague, are immobilized, dumped on bodies fused to the duration of their death—rather than to the duration of an imagination of death in which their matter consists; just what the Deluge wipes away, that it pulls together on a same stage in order simultaneously to efface it.

No sooner, these are two humanities, side by side or back to back, that form a history, that are being divided, that are being mortified. That invent *mortality within history.*

Thus, we have a single body, a body cut to death in two contradictory shudders: a stupendous death, a death of the Titans; a death in the most minute detail (a second death under a magnifying glass—the puzzle, the uterus, the storm, the paradigm).

≋

One part of the fresco turns its back to the other. Between the two sides or upon the *dorsal line,* there are the ramparts of a fortress: a lesson in poliorcetics, a lesson about taking siege of the city of Pluto, Ditis, closed in the middle of Dante's Hell.

The city of the Deluge? "The tower of Babel . . . a result of an effort to reconcile the diversity of languages with the primitive unity of the human species, a dogma basically tied to semitic monotheism."

The body of Babel? a brown body, flaked by scales and enclosed by the beater, is seated in front of a wall, directly facing the screen of plants that cast a shadow back, and fused, on the turd that it pushes into the water.

DIVISION OF THE BODY, DIVISION OF THE GODS

How can Saint Augustine show that the crowd, that the scenic crowd, is vain and grotesque labor (struck with hollowness) of the ancient gods?

Above all, it appears as if the immense work of mythology were succeeding only in separating all bodies, in engendering them *over voids.* In the first place (or due to a first effect) because "mythic or 'fabulary' theology contains many fictions contrary to the dignity and to the nature of immortal beings. Here we meet a god borne from a head, another from a thigh, another grown out of drops of blood," and, as if this abusurdity did not suffice (since it carries a prescription only to the image that cannot resemble a single man, a single standing, beating, walking body—est ut deus alius ex capite, alius ex femore sit: the god of what body?), everywhere the former division grows endlessly.

It is still because the division between mythic, natural, and civil theology advanced by Varro is only, is *already,* a division of a body greater than all of its parts; of a body that is not made by gathering its members together. The absurdity (the opacity of a literal meaning in which men jump in order to respond to the gods) is held, guarded by the metaphor of the "signifying body," of the theology that is precisely bridging the figuration of the gods with the scenic evidence of monstrosity. All of Varro's theology thus converges onto the stage; the gods are pressed together on the proscenium because they seek the likeness of humans. "Thus civil theology is reduced to fabulous theology, this theatrical, scenic theology (and if the catalog of the gods knows this descent it is precisely because the stage becomes the site of their figurative crisis: *theologia fabulosa, theatrica scaenica) revocatur*

igitur, because a voice sends it back; full of ignominy and turpitude . . . and the one that is deemed entirely worthy of being condemned and rejected is only a part of the other . . . and not, to be sure, a heterogenous part . . . foreign to the totality of the body . . . but in perfect harmony, consonant with and linked to each of the members of this body" through something like a "copula," copulata: by a bridge of flesh, through a conjunction (as if, in its mass and its unique and impossible figure, the fabulous body were nothing but an immense tale). "What do we see that is different in these statues, these forms, this age, this sex, this clothing of the gods? quid enim aliud ostendunt?" are these separated members not surely the rationale for a body, its proof and the very reason why the arc of this metaphor crosses over and again and continues to extend the catalog of mythology? the body of theology (what these statues display of the gods and what they display in fragments, in little pieces) is only the support of a metabola that assembles, but without ever being able to sum up, the dispersed gods.

There thus remains under this bulging anatomy, an arching in a skylike way, a chance or one more derision given to the theater. "Aren't the functions of the shattered gods, in accord in such a cheap and exacting manner, with the buffoonery of the mimes rather than with the majesty of the gods?" (Thus, those who are held in view of the gods have to mime, and mime tragically, all the way to the end of these unnameable things where a divine body can be tightly held.)

The comic theater is hence just that: an infinitesimal, tenuous division of the body over its functions? And thus, in return, the general body of articulations is the extended fiction of every species of god. The fiction of a totality, since these gods cannot be properly added up together, that the gods somehow immobilize an imaginary division of the species, constituting a superstructuring of human animals. (*Nonne scurrilitati mimicae quam divinae consonant dignitati?* where, then, is the identity, in what direction does the image fall?) What is theatrical and, within that theater, the silent gesticulation, is this excessive plural, an additional scansion, a division that cuts only one imaginary body and that in its turn can scatter a shameless body into astral sparkles:

an arm, a thigh, a phallus, a quartered mouth, the sucking of milk, an elbow. All these gods are not only convoked upon ridiculous, grotesque figures in order to figure like jumping jacks on a stage where they are cutting up the pieces and gestures of a single body; but still they do not succeed in uniting this body (the one that is only a kind of broken, dismembered mannequin of allegory), cause it to stand up outside of itself (*thus* this type body has no moral principle), they send it back to an ecstasy of monstrosity. But still what is this scene? monsters that can't do anything together, but that are all detached from a single trunk or torso that cannot be seen. They are piled up here in the Deluge. Only their collective assembling is monstrous because, together, they represent the conjunction (and not the articulations) of what would be an *absolutely white* body.

What is the effect of this clutter of gods? How can civil theology be distinguished from fabulous theology? the cities from the theater? the temples from the stage? How can we depart from the fable if the gods are these bodies invading and buzzing like a swarm? urbes a theatris? templa ab scaenis? Is it not through the song of poets that mythology (an immense body that turns and, from one revolution to the next, lets its members hang and fall away) is an image of civil theology? But does this image send back only one face that is no less scornful? And then who made the painting? who began it? Ipsam faciem: this face the gods themselves, by looking at one another in the same mirror (on the same stage), adore so much that they are known by it (qui qualesque videantur: something more than Narcissus because, in the curvature in which the faceless gods *are leaning,* this movement contains the body of Narcissus; it obliges him to tear his limbs apart). A kind of shrunken scene, slightly moistened (the gods recognize one another because they are at once the temple and the stage, the theater and the city); these spoiled bodies, these truncated animals, altogether, are gazing upon their face for the first time, a single face, this one: ipsam faciem.

(in its turn, what scene other than the one in which all the gods see a single face in the middle of a crowd? of their park? what primal scene, what fiction of a return, in short, what childhood memory can do *that*?)

PALLOR

Pagan theology is thus the *disharmonic sequel* of the unknowable gods. Since there, in the very spot where the gods can be seen, their bodies fritter away. What then is a figure *if it is dividing*? Seneca's testimony according to Saint Augustine: "Worship is rendered to sacred, immortal, inviolable beings in an absolutely vile, inert, immobile matter; they are endowed with the form of humans, savage beasts, and fish; sometimes a double sex—and in this way they are thus *divided twice* in their image—, composite bodies; and these beings that would be taken for monsters are called gods if, once endowed with life, they were suddenly to come forward (*si spiritu accepto subito accurerent monstra habe-rentur:* if, in one movement and in one breath, they began to run, were taken for monsters; and . . . if these monsters *began to run*?)." What, then, *in this monster,* has the painting retained of the matter of a worship? The most impalpable matter, that which, with one more aberration, Hostilius has consecrated. (Dedicavit Hostilius Pavorem atque Pallorem—*he made gods out of fear and pallor* [taeterrimus hominum affectus]—the most repulsive human desires, one is a movement of terror: is it not in this chain: taeter, territus, termentum, terra, the entire etymology of *earth* in Varro? [alter corporis ne morbus quidem] and the other, not even an illness: rather, a color, sed color.)

Among all these bodies (habitus hominum ferarumque et piscium, quidam vero mixto sexu, diversis corporibus induunt) *are figuring,* in other words, out of this swamp, rise the two subtle gods of the skin; those who preside over this latency of the mythological body, the one who, in his digitation, receives its effect, these two conjoined sensitivities of each of the two sides of the skin, terror and decoloration. The fear of touching the body of mythology is thus a movement stricken with plague (the terror *of touching* the divine immersed bodies in the fable is already a fabular body): it paints this body, it soaks it, it washes it. A windy effect grasped to the point where a given god is smaller than the imagination of a body, but feverish, retracting, its teeth clenched. That the effect in which humanity receives an immediate terror (in the impossibility of *only seeing the image*) on the skin. Who, then, in the infinite proliferation, in these fibers of cut-up skin,

has invented the painting, and invented it upon this effect that is not even an illness—ne morbus quidem sed color?—but a color? The fable has an answer, but so also does the signifier: the fear of reading and touching the truth of the mythological body, in the way, wrote Artaud, the terror of meaning draws pustules on the body of humanity. And why, for that (ne morbus quidem), for this "nothing," for this pallid color, was a god needed? a god for decoloration? It is because, justly, like all the gods crowded and piled together, they mix their voices and their poorly drawn members on the theater, the stage, the temple, the body that they are scattering, that they are crumbling as an image on the fragments through which *they adore a face,* the fear that descends, the pallor that colors, all that comes, surfaces, illuminates a little, and is extinguished. Because the body does not think of itself, it is painted. (Hence some grotesque gods, cut in all kinds of positions, with countless fingers turn their mica under their extended skins.) There is a god left out of the catalog. P like Pallor, the subtle god of the plagues—the one with an infection that is not an illness—the one who paints in white.

What, then, has this page learned? A god named Pallor who invented the way to paint bodies in white, and because this color is called a condition of feeling. A feeling behind Seneca, in his back, that Augustine finds (for the destruction *of the remainders* of scenic representations of the body, of unthinkable remainders on the whole) ignominious.

What is the effect of this pallor (of this thin god)? Probably one that tells us little or nothing about the painting. But it reiterates, again and in another way, everything that I know. Because the language in which one labors is, too, also an unstable material. That thus can "translate" and, as it happens here, be destroyed.

Seneca thus says that an improbable god had to invent and to cause bodies to turn pallid. Or else to be the name of this decoloration. But that is not yet the god of the Deluge (the god who comes before the painting? the god of cosmetics, of flour-white makeup).

MIMING

Passages of obscene rites (those that Lucretius represents borne from the plague's moment of madness): where men who are re-

turned to the images of this fabular theology, right where the gods adore a face, amputate their members, are detached piece by piece, and offer these living parts to the faces bent over them. Thus, these men, sent back to the bloody labor of division, of apportioning (and of a division that seeks to *represent a soul* on the theatrical stage), say that in this dramatic episode they are precisely nothing more than images; they are sectioning and cutting in the flesh of the images. At the same time they say that between the mirror of civil theology, the stage, the temple, and fabular theology, they are also the image whence *anatomy* is sought; because they do not have the slightest place in a language. Hence they cut with a knife, with a shearing of teeth: ille viriles sibi partes amputat, ille laceratos secat, that they are seeking and extending the anatomy from their members, the stippling of this image, crossing through mythology over amputated bodies. Primal scene of this painting: gods, monsters to be destroyed, that lean over while smiling in quest of the face on these scattered members. Rescue this man sunk under the weight and on the strip of an image. But how can all of this body be tied together, unless through recourse to another idiom, to an allegory that divides it only along the line of its meaning? In mythology, in which the gods would be only so many *paragraphs* of the body, is there not a figurative pressure maintained that, aptly, is *blinding*? the same holds for this sacrifice of anatomies, of tragic sections, and for the insecurity of the image that works through the painting's bodies?

Or, even still, what is this mute scene, translated into silence, prescribing at the Capitol? Far from the temple and the statue of Juno, out of this distance women twitch their fingers in order to adorn Juno's and Minerva's hair. After all this tweedling in the air, still others extend a mirror to the statues. The love of images is, justly, so strong that they split in two the human body on the stage, such that they require it to *mime.*

≋

(where does this critique lead in the City of God? Varro's theology and his mobile referent [mythology] are not examined at their origins, their history, or their progressive genesis [transforma-

tion] up to the status of religion. The mythological beings are taken, animated in the language and etymology as a *complete signifying body*. All at once, a poetic [technical] critique and a critique brought to the fiction of their structure can nowhere be found. The object is probably no more than a discarded remain of the poetic body that now can only "induce" its literality: the place of this signifying body in the Latin idiom right *where it is no longer prosodic*. This riddling thus forces it to exit from the poetic body [isolating it, making it fragile]: a body of this sort is perhaps condemned only because it represents a fattening or thickening, an encystment, in Augustinian syntax. The displacement of this poetic anatomy is already—for me—or: *is only* the testimony of its labor in painting. This is not the staging of a remainder; rather, everything that remains unwritten in this body is working, nonetheless, through its signifier.)

SALIVAS

"There still two gods exist, but I can't tell which, that are very obscure, a Vitumnus and a Sentinus, whom the first endows the fetus with life, and the second, with its senses. The astonishing thing is that, although they are the most obscure deities, they offer a great deal more than so many other eminent and chosen gods: for quite rightly, *sine vita et sensu,* without life and without the senses, *quid est enim totum quod muliebri utero geritun,* what's at stake for every thing that has grown in a woman's uterus? nisi nescio quid abjectissimum limo ac pulveri comparadum? a kind of comparable abjection, or rather: something to be tossed away that is born with silt and dust" (tossed right into pools of muck and turd. The entire painting on a single linen, a shroud, a cadaverized skin).

(detail: the uterus of the fresco)

The matter concerns a coming-and-going, a movement of the language, of a valve; of a vulva: excreting bodies browned by its waters in the silt or uttering them. From the birth in the lagoon *[lagune],* on the tongue *[langue].* From saliva, and from this mushroom sprouting in the uterus.

Thus, we happen upon the gods of the ebbing tides, going through the mouth, that recede, unfurl, and froth. Before Salacia and Venilia, there is Janus' mouth—ego sum junua: the door.

Propter solas salivas colatur hic deus? in short, is this god worshiped only for the salivas that he offers? two pendant doors under the sky of the palace, a saliva that drips down and the other that is spit out. In Janus' mouth Neptune and Salacia and Venilia would be concealed, and when the jaws open the tempest comes.

All these bodies are piled into one another, are telescoped, and interpenetrated: they are all greater and smaller, an indefinitely unfolded, unraveled body of the same skin, a body that consists only of what it is beating, an image that is ceaselessly alternating. For example, Janus spits Neptune on his tongue, Liber and Libera bail out this slimy substance. Venilia rummages about under her tongue, Vitemnus tries to blow on this thing that has sprouted in the uterus; a sky on the ceiling of the mouth. Ouranos is erect.

In the painting the question is this: (the scene—the fresco—figures the entry of a tunnel illuminated by phosphorous: a lapping of waves continues, a few survivors are swimming, hold themselves up or sink in the sewers. A simultaneous effect of this world, underground, of a landscape under the clouds, under the moon—of a storm under the moon). "Why the desire to have our mouth and our gullet, that the world does not resemble, become an image of the world, its simulacrum, because of this sky on the palace of Janus, since Janus does not resemble his open mouth?" An absurd question. Augustine refuses to have, almost as we have here, several bodies on the same stage that exchange one another, that add to one another, and that change their names. Let paganism simply be the effect of a history, let it be a memory that has merely *come that far.*

As in Janus' mouth—his tongue, his lagoon beaten by two salivas, the one that comes and the one that goes—there would be a god of the Deluge. Neptune between two women; Venilia the water that swells to the shore, Salacia who takes a second helping of salt, heads off. Thus, the red that ascends to the face and the white, Pallor, that everywhere descends. "And if its the same water, if indeed it is a water, the same that comes, that goes, why make two goddesses?" "Now although this water that comes, that goes, is not double for the soul that comes, that does not come back: a hollow swirl, is twice defiled." "But the water that comes to the shore, that returns to the sea: is it two parts of the world, two parts of the soul of the world?"

In the place where there is a birth, a mouth, a saliva, a water, the Deluge is entire. Above all because the fresco will have only accomplished this: to float between Varro, the plague, Nerval, and others, in its writing. The body of the painting thus will have been uniquely *tossed about*. Because I am stopping that, the reading (*De Civitate*, 6:vii) before returning to terra firma, Tellus ("a great body no less, and filled with animals, the lowest part of the world"). I stop here, at the same time as the painting, in the open mouth. On the waters. On the Latin: how *can the waters be divided*.

(and the line goes back, along a cord, back up the whole page: the saliva, the babies thrown in the mud.)

MAZZOCCHIO

B eyond the body of a synecdoche (a fossil body, cloaked with feathers of cloth, with a beak, erected on skids), there is in the Deluge: another skin (of the plague), several bodies and animals, a statue, a perfect object (neither perfectly round nor totally square, but absolutely enigmatic).

≋

The mazzocchio is a figure; not being divided, the figure has no soul. It is above all a classifying object that accompanies the degree of displacement of the objects of painting.

The image, or what might be called the iconic body, has a manifold engaging mechanism, because each body activates in some way what are only metonymic short-circuits—or the body has only a short command over its metonymic circuits: it gets lost or consumed in them; does not resist variation: this chain of variation is not a combinatory chain.

The catalog of painted objects (it classifies only the species that it produces) is a prospect of bodies of memory (memory of the fable, of the fabulous, anonymous body). A catalog in which the inventory of the sites of memorial protocol would be defeated: there thus remains in the waters of Lethe the confusion of what memory sets *afloat*. A paradoxical catalog survives, that of the movement of heterogenous bodies.

Memory, the enormous pocket of separated species, is only the site that loses them (the painting of mythologies, of a symbolic extravagance of the species, through precipitated condensation, displacement, jelling, of bodies on heterogenous myths—there also exists a history of the symbolic datings inside of a painting—; of bodies stuck, foliated between hell, the deluge, the plague).

Here is where the mazzocchio plays a role in the narrative or mythological improbability. A sign of the impossibility of illustrating a single prehistoric or historic catastrophe, drawing a

paradigmatic bar as a "phantasm" of a gap in history; it thus points to the flaw of the figurative body (in the manner that it has of emblazoning it, in making it equipollent, in quartering it), the mark, the indicator of the selection of another subject, seized by the representation of another symbolizing order.

Related to the relatively ataxemic sum of the all the figures, this mazzocchio, composed of a preeminence of relief on the proportions of the bodies, on the angles, arcs, and red-brown colors, is thus mobilized as a *complement of contradiction* (in excess: as in sewing, it is the underside of the flatly woven seam on the surface, on the front side) over the sum of the figures. The monster's place, what was to be below, now surfaces—a contradiction in the morality of the art that, according to Vasari, is borne by the excessive interest in these objects, which lack all sense of proportional grouping; the art would be above all that of concealing the mannequin, the junctures, the threads; a whole scheme of support (here it is a scaffolding that stands up on its own, a prop that no longer supports the fiction) that it must erase from the figurative system because, in Vasari's idea, it would sustain a logical contradiction to the painting: a contradiction of existence; because it does not induce its own transition in the painting in terms of values, of contrasts, of local tones: it indicates to the extreme only the impossible cohabitation of the figurative field, as a logical field of presupposition, with the pictural field. The body of the subject of the painting is not displayed as a figure, as one more body in the immense waterline of the mythological body. Rather, it is merely a kind of buoy, made manifest across an object floating in the painting. Even if Uccello probably surfaces twice in the bust of Noah, in the effigy and statue of Dante— Dante crossing the Acheron, slipping along by virtue of a pair of hands, with his hands, by one of the painting's animals that peers up under his toga, like another of the painter's blazons, of which only a head and hands remain.

According to this metonym (this rebus that inspires the painter's travel over the disappearance of several bodies and over their conditions), he is most of all, in a signature-effect, uniquely probable *outside* of the iconological interpretation, indicated as *an instance of counterposition* to the figurative field, in the mazzocchio.

What remains next to the body of the painting could thus be the revelation of its heterosemia (a reduction of its place, to a figure in a catalog and in a fiction). What remains of Uccello is a mazzocchio, a hairpiece, a buoy, the instance of a level and of a style of labor aimed at the "flaw" of the body. Here the floating object, hanging onto the thrust of the bare bodies, is a projected twist (*precipitating,* the only truly unclassifiable term, not through its place but through its figure); in the order of the figures, a twist projected out of the probable referential field. A prism that endlessly *borders,* through a supplementary calculus, through a stippled drawing, a remainder of Uccello; that masters the destruction of the mythological organism through the return (and excess) of a nonfigurative symbolic activity.

Representing an instance of an order of differentiation, the mazzocchio (and its relief is probably only one of deixis of positioning) happens to complicate, or "complexify," the figurative field *as* a fictional field, to open up its network: a measure of the *introduction of a heterogenous element in a totality.* It is this emblazoned figure (a *tortil,* or twisted heraldic ribbon, a rolled-up checkerboard) that arrests, clots the other bodies with an effect of excessive prickling. Its function is thus one of playing on the figural plane as the already expired end of a referential iteration of the elements of painting: the constitution of a differential position through the indication either of an *increasingly arbitrary*— or the most differential—position of a nonrepresentative element, or an element that is progressively cleaned in respect to the sum of the figurative field.

That is why this almost round polyhedron is the indexical sign, the tropism of another order in the plastic milieu; continuing to play on a very Euclidean (and Dantesque) indistinction of form, of geometry, and the most complete since it *orients* the figurative field in the direction of its differentiality.

A body turning under the bodies, a prism sparkling with facets: what *remains* of Uccello's body (the deictics and the repeated twists that restore a system, a kind of rennet in the milk of the painting: the entire possibility, the entire utopia of a system holds to the unlikelihood of integrating *an unknown element*). This object *cuts* into an amphibolic matter: the body, the figure. Its nega-

tive selection, the prevarication of the signifier that it bears alone, thus yields only this: it completely disengages or brings forth the entire body of the fiction.

≋

On this object thus we see constituted the signifying body of the painting. Perhaps the only one that is posited as a body: and here is its proof: it does not translate, hence it is not entirely a place. Here the signifier has a neither *catenary* constitution or determination, but is the constitution of a new body; this body is not offered to the alternative of a translation—it is taken only in a movement of despecification. And its whole analysis might be reduced to the following: to marking that there is a literal body that cannot be reduced. In a prism, the turning eye of an irreducibility of the body of the painting. An entire body is thus subtracted from memory. It signifies nothing other than this: that all bodies are disaggregated over the historical memory that bears them. That memory is thus a rupture of matter in the phantasmic dimension of the Western body. And right where the plague leads its fiction. (The plague of 1348: the first rupture in the vast and seamless theological fabric veiling the prescription of bodies: all the descriptions of the plague are the staging of an analytical retraction of the body, the extension of its anatomical incapacity.)

An object that is not "being divided as it goes back"; it goes back to nothing, nowhere, it is an amnesia turning in the middle of the painting, of the deluge. Thus, there we see a foreign, indigested body in the painting that has, if not a meaning—for lack of a meaning—at least an emblematic *position* in respect to all the other figures; that thus owns, relative to a totality that can be discerned, a differential position in order to become immediately differential as an object: *the instance of the referent that it seems to articulate in the body of the fresco is not an instance of the real*: it is a referential instance of workings that tend to "engender" in exemplary fashion (i.e., equally upon an etymology) a module of the signifier. A traced figure that can be delineated, a voluminous, definable figure according to laws that are not that of the fiction, that are thus not binding in the figuration understood as "istoria." The only body that does not travel in the Deluge, that is not

affected by the obligation that all the objects have of moving out toward their own disaggregation at the end of the deluge, on the right side of the fresco, on the sand, the joints crushed by an angle of the wood.

A figure, a concretion is thus referring first of all to a *geometrical* operation (autonymous: the sketch of the mazzocchio as a figure, in other words, as an enigma; an inhabited body. It is not a top and, if it spins, the imaginary gyration does not make its voice audible, the whistling of the wind, its mast: the mazzocchio is only the *symmetrical and narrative "pendant" to the statue of Dante-Uccello* issuing from the Deluge). The "instance" that it is representing is, in the first place, grasped as the topological ring representing the subject in its effect of death.

As of this moment we have the production of a scene in the form of a lozenge; a stage—but not a theater—of the apportionment of bodies over its geometry: the giant annulated by the mazzocchio / the statue, the woman with the mazzocchio, the man climbing out of the barrel. This distribution in the shape of a square, the geometrical distribution of the bodies, this kind of minimal exchange of roles, is an exchange of hysterical functions—the supplementary production of the body for the scene; each of the two actors in the center gazes at its other, or the exit of its own monster on another body. Here the second body is always a "gigantic body." (Or, according to the etymology of the *Nuova scienza*, a body that is monstrous only in order to be born into the monstrosity of itself: to be only the unnamed body of a classifying order: the body that is *derived*, or drifts away, from nothing.) The woman gazes at the annulated giant, the man in the barrel at the back side of the statue; these two oblique gazes congeal a scene and refer, through this space of colloquy, on the degree of the body's caseation to the geometry, *to their own lateral depth:* the extended paradigm (on the arc to the left) of an undressing of the body, of a dislocation from its shadow, of its decomposition and wrenching away from its double; up to the point where its *nature* is somehow "infected" on an ultimate stage in the background, *on the island.*

This island is in the first instance the classificatory limit of all the objects shown: striped on its position by vanishing lines, the

island that floats in the background of the fresco is no more than the typological impossibility of another sum of figures in the totality of the fresco: it is the *ultimate* theater of amphiboly. The only figures therein are bodies, but bodies that are in some way seized by a power of separation (engenderment or defection of the figurative body and of the fictional body). Here nothing of what is the history of the same deluge is told, the actors ceasing to be affected by a role on their body, the last gesture being that of the order of another catalog; here every possible detail is replaced by a body. We see the site of the success of the paradigm, the countertheater of the diamond-shaped scene on the four bodies in the foreground: the fabulous states are now nothing else than minimal species—the catalog of the painting. A piece of clothing heaped on its folds, on a body, an animal, a white body, its back turned to its blindness, a black body; two bodies that exchange no longer as other, as shadow, as negatives: in the background of the fresco, that holds on a floating island an amniotic state of the bodies of its painting, of its narration, of its adventure, the contraries are now no more than bodies kept in reserve, heaped upon an impoverished lexicon. *A scene of species:* held in reserve on an islet, they are like the floating and the insular drift of a memory of a species of the signifier; a scene of the emblematic balancing of bodies, of figures, the fiction of a reserve of the signifier, theatrically annulled upon this trapezoid (on this money changer's table). The end of the fiction, of the painting, and of the geometry is thus at once the little island of the signifier, its floating memory on the bodies that we see congealing there, the little catalog, and the blazon: there the end of the painting is at once the eye of the paradigm and the eye of the storm.

It is toward this mortal scene (it effectively retains the bodies while murdering the roles) that the beater is navigating upside down on his platform: with a thrust of his club into a swarm of foliage, he veers away, still erecting his luminous body, knocking on green tufts: an immense brute, blind, masked by a black pasteboard, retreats under the force of the spinning arms of the windmill; like a child imitating a locomotive between its teeth, its arms like connecting rods, like flywheels, with a huff, and a puff, I think I can! I think I can! push, push back toward this island

where, yes, everything, a desert of crumbs, folds, collapses, falls (from a body completely, heavily coped, with a sheet, escapes to the right of the trapezoid, one foot undulating under the wrinkles of the cloth). With this club turning upside down, against a lathing, against this planed, smooth cheek with a grainy texture, in profile, is subtracted only the body of the wind: a baby that runs to the right—a kind of eolian child, inflated like a cloud—with feet of mist toward the center of the storm: what, then, is the color, if it is not, as for the naked bodies, the clothing, the liquids? or even: all the pasty shapes, the compromise of a matter that *is arrested upon the passage of a body.*

It is thus because no process is affecting the figurative bodies in their relation with color, but of all bodily engenderment over the primary indiscretion of its matter: the only function that figuration possesses is one of being born, in other words, of being defectible. And the matter is born only in the duration of a fable, that of the birth of humanity plunged over and again in an immense amniotic bath: here the body is, *for its moral ethics,* the effect of a calculation on a slightest anteriority upon its matter: that is the unique lesson of the color—the color has neither degree nor local tone—but *states,* and in their turn these states, are substances. And, inasmuch as a fold or a wrinkle may touch them, these substances are now nothing other than defectible. What, then, is the lesson of a physics that is replacing the entire ethics of the figure? It is above all that the body prior to or subtracted in this latency of the figures in matter is only the *geometrical monster,* the mazzocchio, but still the floating and topical impossibility (of situation) of the crystalline body of geometry over a duration of expanding colors.

If the quartz is not set in the lesson on colors, or if it is not placed among the other bodies, then what is the effect? It is classified only in this strange "discrepancy," or interval, of a physical revelation: what kind of matter are we dealing with? It is a kind of discovery. Like Giordano Bruno's cosmic matter, everywhere it is the same, is affected with an equal amount of time, annulled by this infinite distribution: the bodies of the painting are luminous through reflection because they are *beneath an eye:* this ring is in itself luminous, it is a monster, a giant, yet it is *the crenellated eye*

143

of all the bodies in the space, the enclosed, annulated secret of their alternation with death. The turning, cyclical alternation of black and white, of the two limits of the chromatic imagination: what thus is locating all the bodies that it sees outside of the color field; *outside* of its expansion, of its duration; this eye in the crenellations of color here can thus se⸢ the bodies of mythology only as the *site*, the ochre, yellow, ⸢⸢ *loudy* site of its arc.

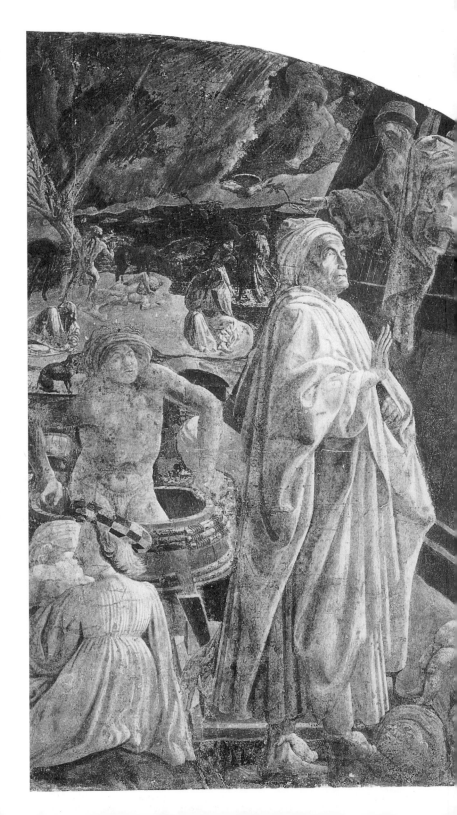